ELTHAM
THROUGH TIME
Kristina Bedford

AMBERLEY PUBLISHING

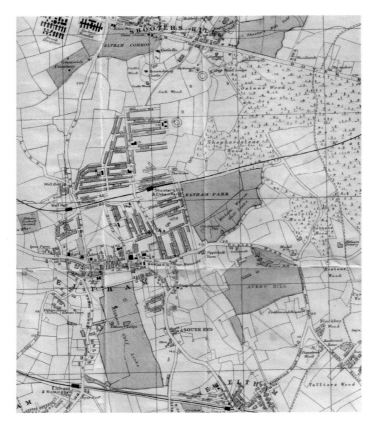

Detailed Map of Eltham
This segment reproduced from G. W. Bacon & Co.'s *Large Scale Plan of Woolwich, Including Plumstead, Eltham, Blackheath, Bromley, and Chislehurst* (no date, *c.* 1920) demonstrates the still rural character of Eltham during the early twentieth century.

For Ken, gallant bearer of iPad in scabbard ...
everyday, everywhere, in all weather

First published 2013

Amberley Publishing
The Hill, Stroud, Gloucestershire, GL5 4EP
www.amberley-books.com

Copyright © Kristina Bedford, 2013

The right of Kristina Bedford to be identified as the
Author of this work has been asserted in accordance with
the Copyrights, Designs and Patents Act 1988.

ISBN 978 1 4456 1600 1 (print)
ISBN 978 1 4456 1609 4 (ebook)

British Library Cataloguing in Publication Data.
A catalogue record for this book is available from the
British Library.

Typesetting by Amberley Publishing.
Printed in Great Britain.

Introduction

Eltham lies 8 miles from London on the Roman road to Dover, within the Hundred of Blackheath, historically in the county of Kent, but subsumed into the Greater London Area in 1965 as part of the Borough of Greenwich, previously falling within the Borough of Woolwich from 1900. Its ancient parish boundaries touch Woolwich, Plumstead, and the extra-parochial hamlet of Kidbrook to the north, Chislehurst to the south, the extra-parochial hamlet of Mottingham to the south-west, Lee to the west, and Bexley to the east and south-east. Its manor covers the entire parish, including Mottingham and part of Chislehurst.

Eltham was entered in the Domesday Book as Alteham, a fusion of the Anglo-Saxon words 'Ald', meaning old or ancient, and 'Hám', meaning home, abode, estate, or enclosed property – clearly a manor with a substantial history before 1086, when it represented a sizeable community: forty-two 'villains' with twelve 'bordars' (smallholders), holding eleven ploughs and nine slaves, as well as twelve ploughlands, 22 acres of meadowland, and woodland for fifty swine. Held under Edward the Confessor by Aethelweald until 1066, William the Conqueror granted it to his half-brother Odo, Bishop of Bayeux and Earl of Kent, under whom it was held by the sheriff, Haimo. When Odo fell from favour around 1090, his estates were confiscated by the Crown. Ownership of the manor was then shared with the Mandeville family, until John de Vesci united the moieties under King Edward I. After the extinction of his line, it passed to Sir Gilbert de Aton, who gifted it to Geoffrey le Scrope, who in turn gave it to Isabella, wife of King Edward II, after receiving royal confirmation of its grant to him in 1318.

Eltham has entertained royalty since at least 1270, when King Henry III held his Christmas Court at the manor house, popularly known as Eltham Palace. Alternate versions hold that this was gifted to either King Edward II or Queen Isabel by then owner Anthony Bec, Bishop of Durham, who retained a life interest for himself, dying there on 28 March 1311. The royal couple were frequently in residence, and their son John was born at the palace in 1315. King Edward III held Parliament and entertained at Eltham. Kings Richard II through Henry VIII held Christmas Court there, with Henry IV experiencing two particularly 'unfestive' seasons, firstly in 1405, when the Duke of York stood accused of planning to murder him after scaling

Eltham's Entry in Great Domesday
Eltham, Kent Folio: 6v Great
Domesday Book, *The National
Archives*, ref. E 31/2/1/181.

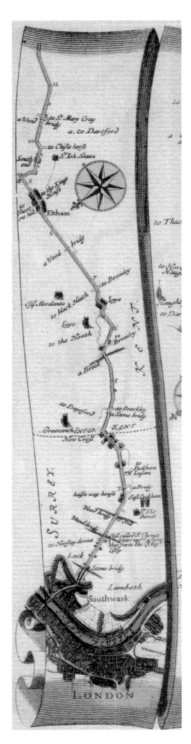

the walls, and in 1412, when he fell prey to the sickness that led to his death. King Edward IV's daughter Bridget was born at Eltham Palace in 1480. It was a preferred residence of King Henry VII; his son Henry VIII generally favoured Greenwich, but spent the so-called 'still Christmas' at Eltham in 1526, attended by a skeleton crew of retainers, having made a hasty journey to escape the plague. The palace continued to receive royal visitors through the reign of King James I and VI, before being punished for its regal associations during the Civil War, when it was occupied by the Parliamentarian General Robert, Earl of Essex, who died there on 13 September 1646. After the beheading of King Charles I in 1649, both manor and manor house were sold to Nathaniel Rich, reverting to the Crown upon the Restoration in 1660.

Though properties changed hands numerous times during the intervening centuries, Eltham's rural landscape remained relatively unchanged until the First World War, when temporary housing was rapidly constructed in 1915 to house the flood of munitions workers arriving at Woolwich Arsenal. Suburban development flourished between the wars, with the construction of three large housing estates, two of which were situated on the former hunting grounds of Eltham Palace. Yet Eltham has retained an unusual amount of parkland for a Greater London community, including woodland at Shooter's Hill and Oxleas, Woodland Farm, and two parkland sites in addition to Avery Hill. Urbanisation has brought both highs and lows to the village, which now attracts shoppers and diners, folk-music lovers and pub-quizzers, but also the looters who occupied its centre during the England-wide riots of 2011, and the racially motivated murderers of the teenaged Stephen Lawrence, stabbed on Well Hall Road on 22 April 1993. Two of the original five suspects were at last convicted on 3 January 2012. A reminder that the turbulent passions of its medieval residents and Civil War plunderers can still bubble to the surface, and that it may be a valuable as well as enjoyable activity to review the past through time.

Road Map from London to Hith
The first strip of John Ogilby's Map, with Eltham featured near the top, pointed out by the yellow encircled star, 'to Shooters hill' indicated left, and 'to the Kings House' on the right (1939 reproduction of the seventeenth-century original).

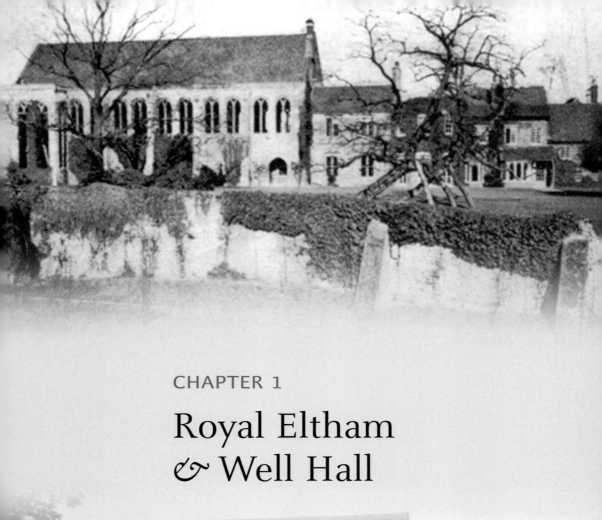

CHAPTER 1

Royal Eltham
& Well Hall

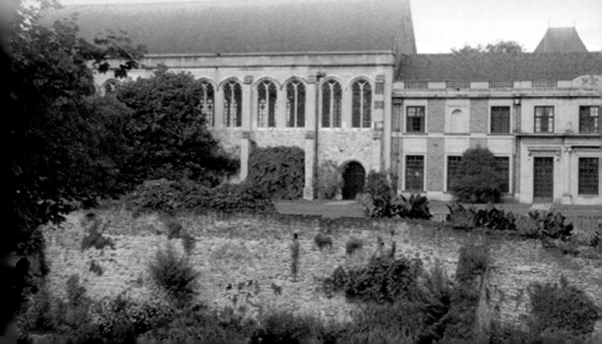

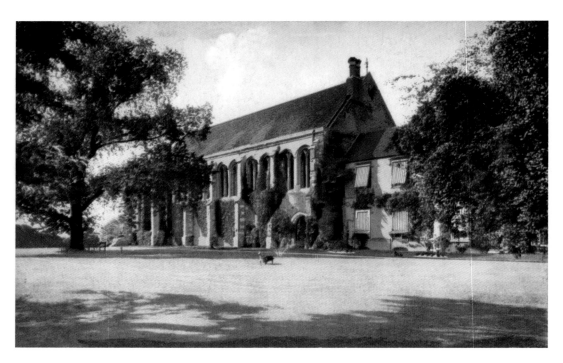

Prince John's Palace from the South, 1915

John, second son of King Edward II and his Queen Consort, Isabella, was the first child of a reigning monarch born at Eltham Palace, on 15 August 1316, and was known thereafter as John of Eltham. The manor house was reciprocally dubbed Prince John's Palace in later centuries, otherwise (wrongly) King John's Palace, confusing his identity with that of his great-great-grandfather King John, aka Lackland, his early death aged twenty leaving little scope for him to resonate in public memory.

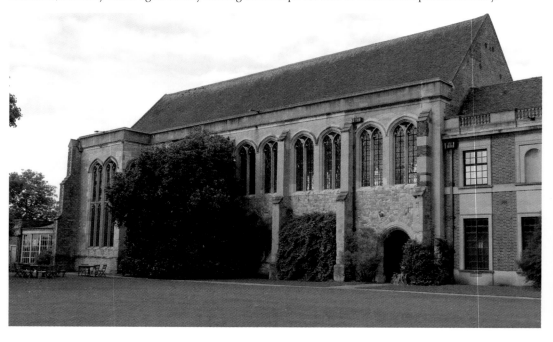

Great Hall Door, Restored

The diarist John Evelyn described the manor as a casualty of the Civil War in 1656: 'Went to see his Majesty's house at Eltham; both the palace and chapel in miserable ruins, the noble wood and park destroyed by Rich the rebel.' The surviving shell of the Great Hall was later known as King John's Barn, a substantial architectural demotion from 'Palace'. Stephen and Virginia Courtauld acquired the lease to the site in 1933, restoring the great hall and gardens.

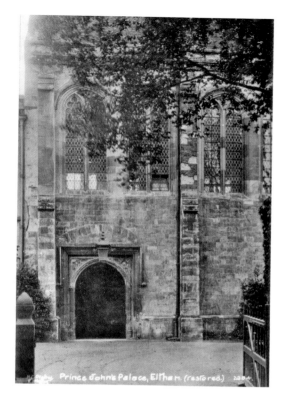

Prince John's Palace, Eltham. (restored.)

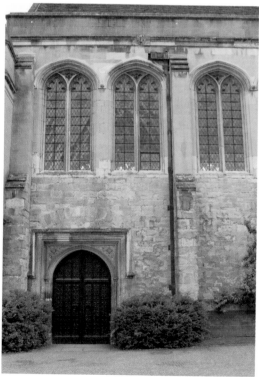

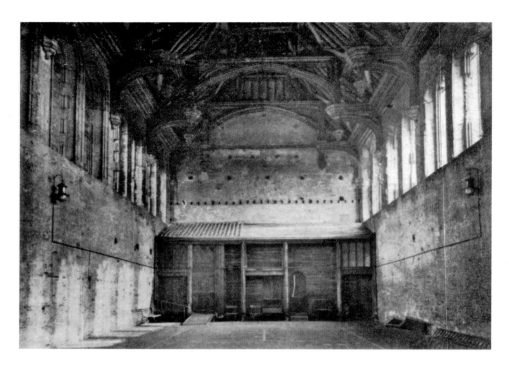

Interior of the Banqueting Hall with Screen, 1909
The great hall with its impressive hammer-beam roof was added by King Edward IV, who substantially enlarged Eltham Palace. His badge of a *rose en soleil* appears on either side of the hall's entrance archway. The principal pillars and beams of the east wall screen survived both seventeenth-century Roundheads and early nineteenth-century decay, with the last carved fragments destroyed around 1818. Its perforated tracery had disappeared before the Society of Antiquaries published a drawing of the screen in 1782.

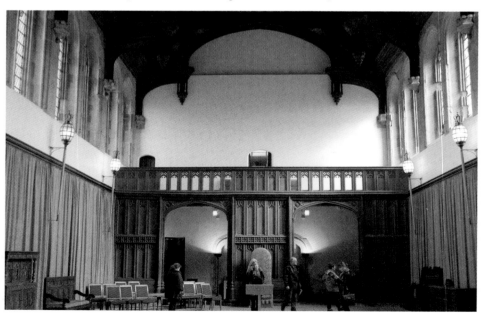

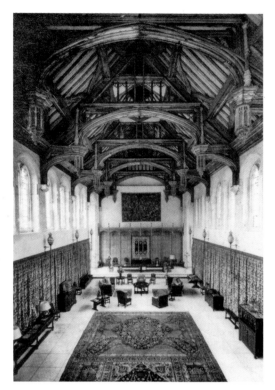

Great Hall from the Minstrels' Gallery, 1937
Stephen and Virginia Courtauld added
the present Minstrels' Gallery when they
commissioned the hall's restoration, building
a new mansion house adjacent to it on
the palace's original site and combining
a sympathetically classic exterior and
elegant Art Deco interior. Its proximity to
the Woolwich docks made Eltham Palace a
prime bombing target during the Second
World War, prompting the Courtaulds' move
to Scotland in 1944. It then housed the
Royal Army Educational Corps from 1945
to 1992, with English Heritage assuming
management of the property in 1995.

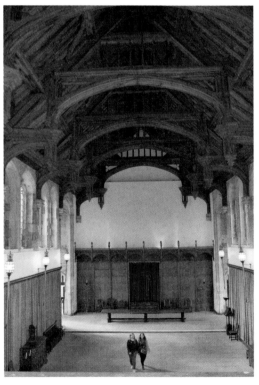

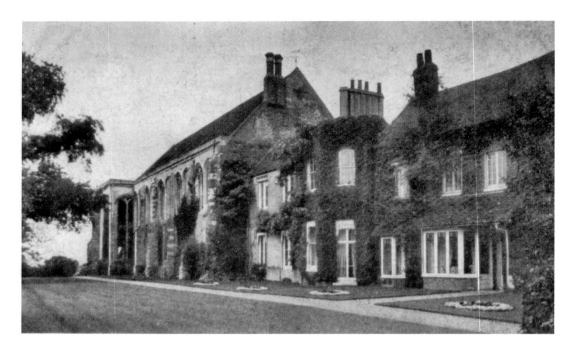

Eltham Palace from the South, 1908

According to oral tradition, the Order of the Garter was founded by King Edward III, younger brother of John of Eltham, at a tournament at Eltham Palace. No contemporary document has been located to substantiate this story. However, a 1347 entry in the Royal Wardrobe Accounts notes the making of 'twelve garters of blue, embroidered with gold and silk, each having the motto, *Honi soit qui mal y pense*, and for making other equipments for the King's joust at Eltham'.

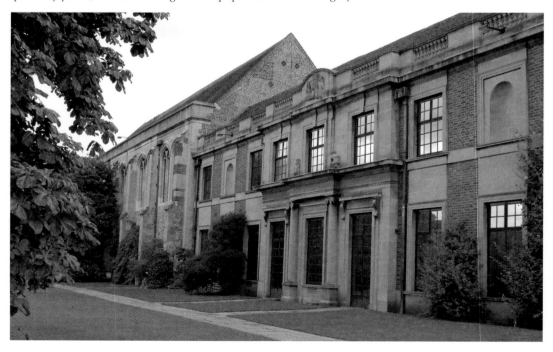

Eltham Court with the Old Gabled Building, *c.* 1909

The gabled building, here directly adjoining the great hall on its left, was detached until 1859, providing a pathway to a farmyard on the southern side of Eltham Court. From this date, a connecting extension was built by then tenant Richard Bloxam, its yard replanted as a garden and lawn, with the southern moat transformed into a rosarium. The structure now occupying this site dates to 1912, and serves as Eltham Palace's tea room, with additional seating on the south lawn.

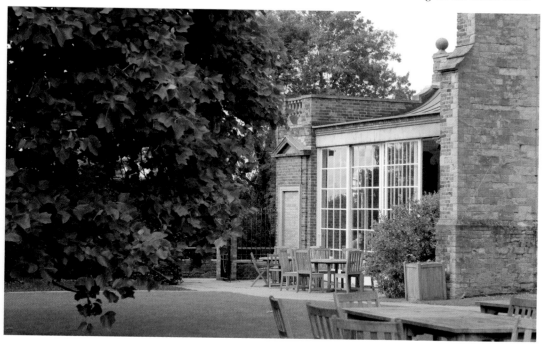

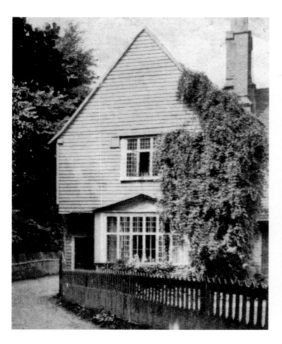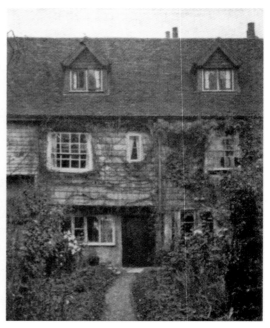

Lord Chancellor's Lodging & Wooden House Adjoining, *c.* 1909
So named in a plan of the palace dating to 1590, the Chancellor's Lodging refers to the late medieval wooden buildings, later divided into two private residences, located on the right side of the palace bridge entrance. Renumbered as Nos 34–38 Courtyard, they adjoin their medieval contemporaries Nos 32–33, No. 32 having been modernised during the eighteenth century. Taken together, they originally comprised a range of buildings that included a coal house, spicery and pastry.

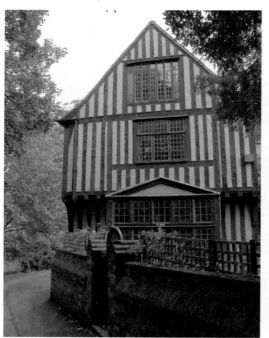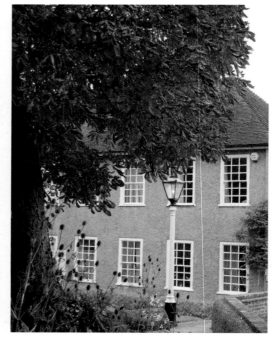

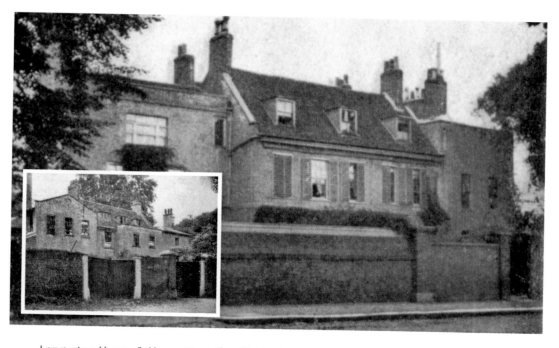

Langerton House & House Near the Tilt-Yard Gate, *c. 1909*

Built on or hard-by the site of the courtyard's seventeenth-century chaundry (a sub-department of the spicery, responsible for the wax and tallow used for making candles), Langerton House survived into the 1930s. The 'House near Tilt-Yard Gate' sat atop the Great Bakery, the yard itself having been a Tudor jousting ground, its surviving gateway and segment of brick wall now protected by Grade I listed status.

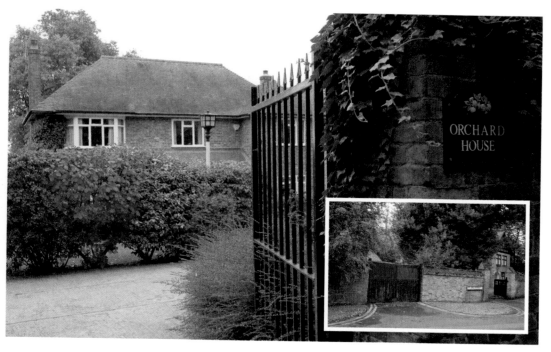

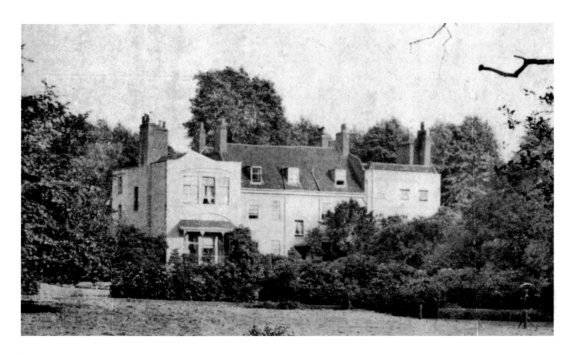

Langerton House, c. 1909

Situated on the right as one entered the courtyard, Langerton House was demolished during the mid-twentieth century, when Eltham Court was substantially redeveloped to provide urban housing. Six dwellings were built on the site of the old chaundry in 1959, their quarters appropriately rechristened as Chaundrye Close. Bramber House, next to No. 32a Courtyard, was erected during the 1940s, joined by neighbouring Orchard House in 1955.

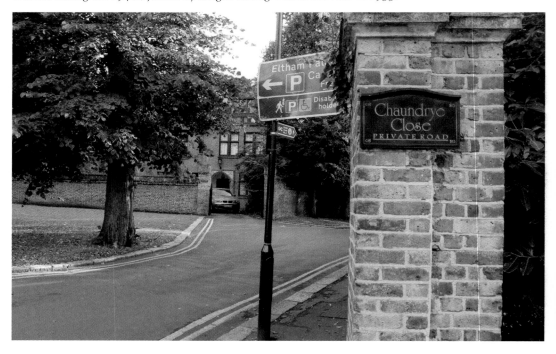

The Court Yard, 1907

Its name derived from the rectangular courtyard built to accommodate the service buildings of Eltham Palace's outer court during the late fifteenth century, the Court Yard still provides the main approach from Eltham Village to the palace, via the moat bridge. The Court Yard is here viewed from the palace end of the bridge, with a colourised version of the Lord Chancellor's lodging and adjacent wooden building pictured on the left.

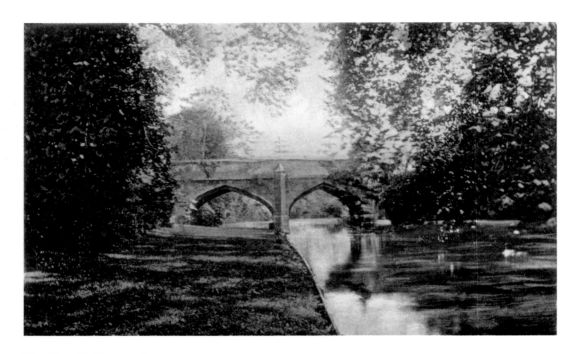

The Moat Bridge, 1908
The fifteenth-century arched stone bridge that spans the moat surrounding Eltham Palace was among King Edward IV's 'enlargements' and, like his great hall, remains one of the site's most important survivals. It replaced an earlier bridge erected under King Richard II in 1396. The old gateway that stood at its inner boundary is thought to have been improved by King Henry VII, but was gradually demolished during the nineteenth century, when the ruined palace's grounds were used for farming.

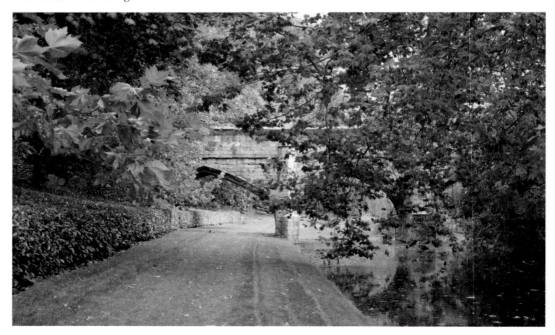

The Moat, 1909

Encircling the palace to provide it with a means of defence, the moat was supplied with spring water piped from the Warren via a conduit in meadowland near Holy Trinity church. It is included in English Heritage's scheduling of the estate as an ancient monument, along with the buried manor houses, the earthworks of the original Bishop's palace, replaced by King Edward IV with his great hall, the remains of the outer court, and sections of gardens lying outside the moat.

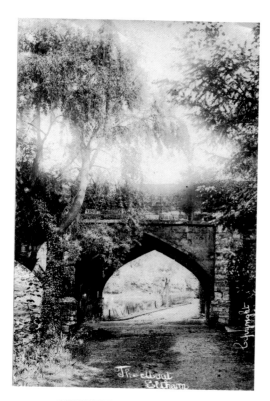

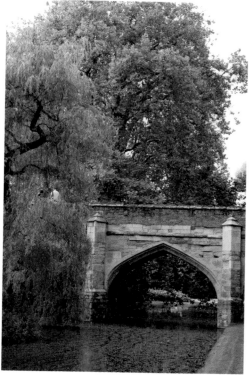

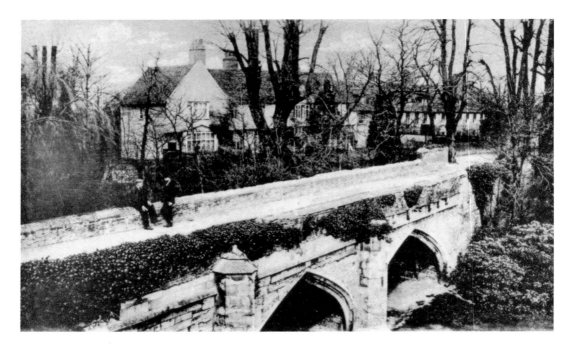

The Moat Bridge

A model of elegant design united with durable materials and sturdy construction, the moat bridge is notable for its four groined arches, which vary in dimension. Angular buttresses sustain its piers. Looking south from this vantage point, one may view the north frontage of the great hall. Turning northward, back towards the tree-lined avenue approach, is the site of the old outer court, whose construction dates to the fourteenth century. The avenue's name of Court Yard is now its only survivor.

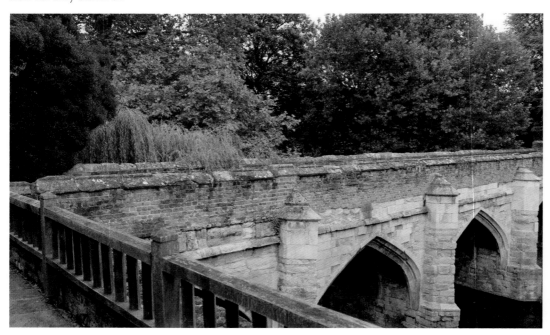

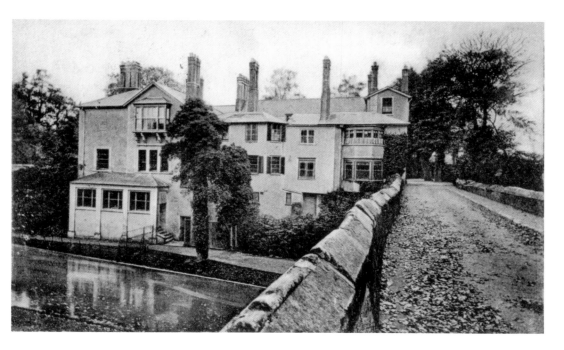

The Moat House, 1905

Originally a picturesque cottage, as is illustrated in old prints, the Moat House was enlarged into the substantial private residence shown above by Richard Mills, Esquire, one of the taxing masters of the Court of Chancery during the nineteenth century. He died aged ninety-four at his residence, The Moat in Eltham, on 21 April 1880. Via his female line, Mills' ancestry may be traced back to the Protector, Oliver Cromwell, whose army occupied Eltham Palace during the Civil War.

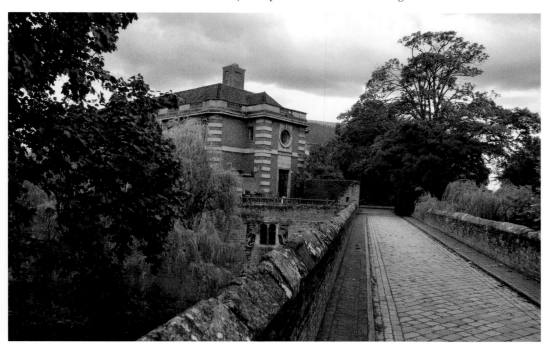

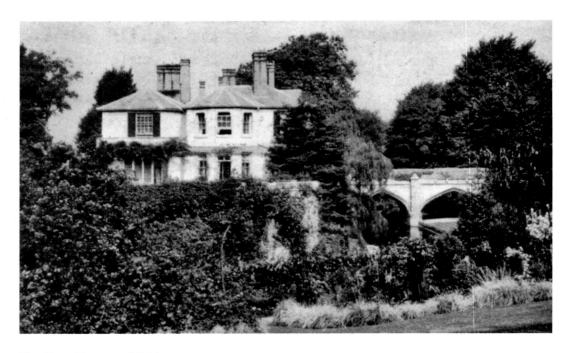

The Moat House and Bridge, *c.* 1909

The Moat House adjoined the bridge, situated within the moat's enclosure. The gardens appertaining to it were located on the other side of the moat, characterised by majestic trees that testify to the great age of the surrounding manor estate. The trees still stand, but the house does not; the new Eltham Palace now occupies this site. The Courtaulds were advised by assistant director of Kew Gardens John Gilmour when redesigning the grounds, which still boast their sunken rose garden.

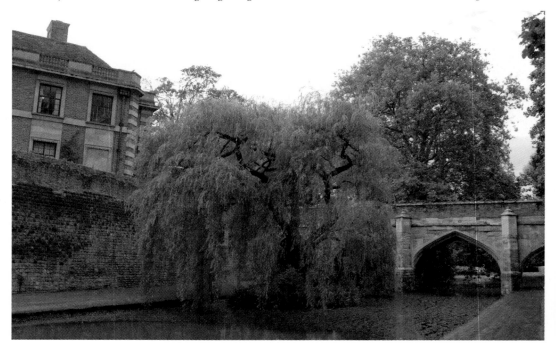

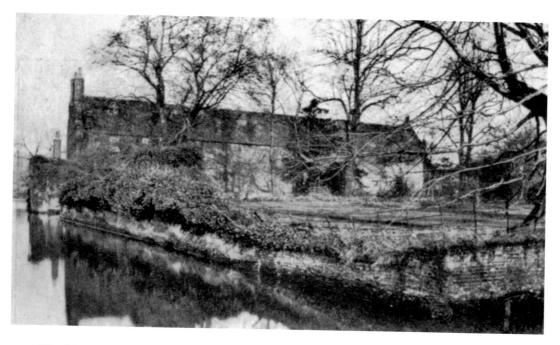

The Moat, Well Hall, 1909

Like Eltham Palace, the medieval manor estate of Well Hall was encircled by a moat, its manor house sitting within the island. Sir Jordan de Briset was possessed of the Manor of Easthorne and Mansion of Wellhall in the regnal year 1 Henry I (1100/01). Held by numerous notable families during subsequent reigns, it was inherited by John Roper in right of his mother. His eldest son John succeeded him as Lord of the Manor in 10 Henry VIII (1518/19).

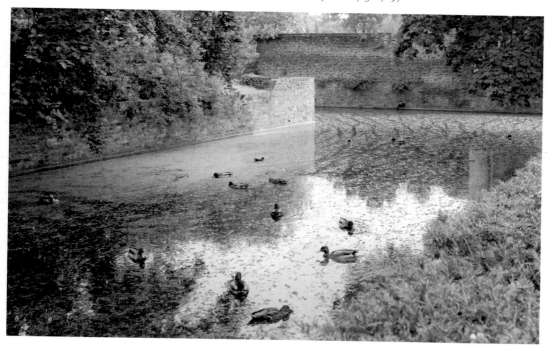

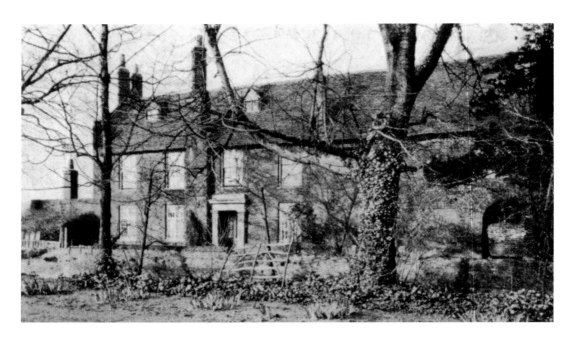

Tudor Buildings at Well Hall, 1909

The view from Moat Island is unrecognisable today, with the Tudor buildings that survived into the early twentieth century having since been demolished and the moat and island reimagined as a community park, incorporating formal gardens, ponds, and woodland, which was officially opened as Well Hall Pleasaunce on 25 May 1933. Its name echoes that of the Palace of Pleasaunce, or Placentia, built in Greenwich by Humphrey, Duke of Gloucester, younger brother of King Henry V, which is the birthplace of King Henry VIII.

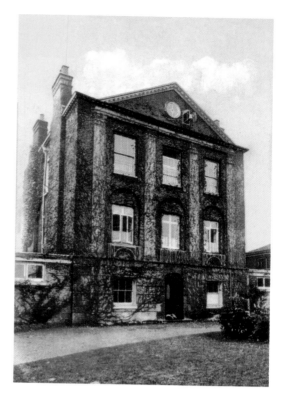

Sir Thomas More's House, Well Hall, 1906
Well Hall Mansion was wrongly known to later generations as Sir Thomas More's House, the fame of its true owner eclipsed by that of King Henry VIII's Lord Chancellor, executed for opposing the royal divorce. Yet, given his ministerial role, it is probable that More resided periodically in the Lord Chancellor's Lodging at Eltham Palace, visiting his daughter Margaret, wife of William Roper, then Lord of the Manor at Well Hall, in what was more correctly known as Roper House.

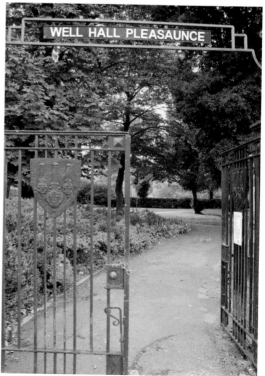

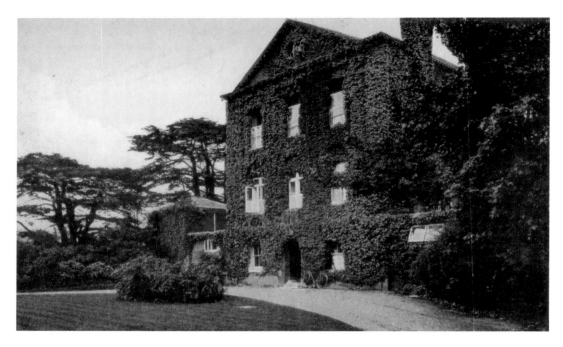

Sir Thomas More's House, Well Hall

The Manors of Easthorne and Well Hall were purchased for the sum of £19,000 by Sir Gregory Page of Wricklemarsh, Charlton, Bart., a renowned art collector, in 1733. He commissioned the demolition of Roper House, which had fallen into disrepair, and the erection of Page House on the eastern side of Moat Island. Page resided there until his death in 1775. The Roper surname lived on in local memory through the Roper Charity, founded by William's and Margaret's eldest son Thomas.

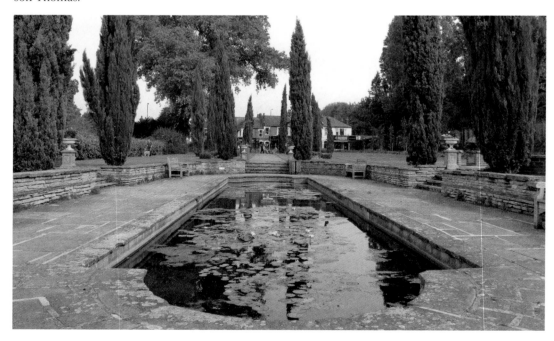

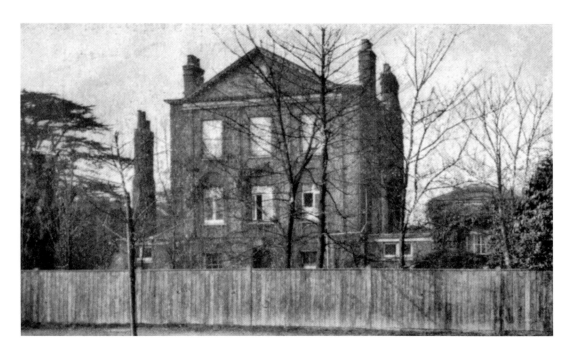

Well Hall House, 1909

Latterly known as Well Hall House, the residence built by Page was home to Fabian Society members Mr Hubert Bland and his wife Edith in the year the above photograph was taken. Mrs Bland remains more famous in her own right as the children's author E. Nesbit. She lived there from 1899 to the early 1920s, inspired by its decaying moated grandeur to incorporate it in fictional guise in several of her stories. Well Hall House was demolished in 1931.

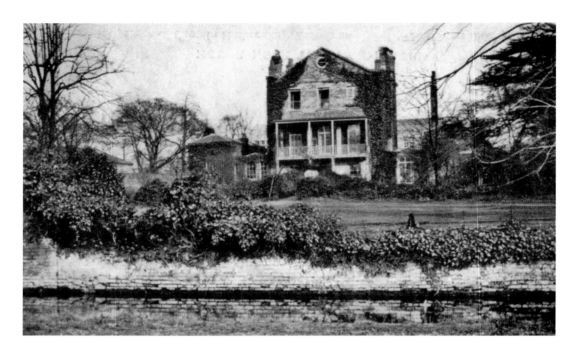

Well Hall House, 1909

The paddock, from where this photograph of Well Hall House was taken, was one of the attendant farm buildings that had fallen into decay by the early twentieth century, and was demolished to make way to make for Moat Island's transformation into the Pleasaunce. John Arnold (1736–1799), inventor and watch/chronometer-maker to King George III, lived at the house from 1779 until his death. He built workshops on its grounds, of which there is likewise no trace left today.

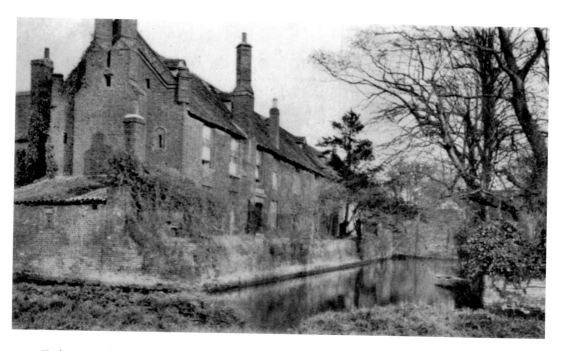

Tudor Barn from the South-West, 1909

Although William Roper is credited with substantial rebuilding at Well Hall, including the Tudor Barn, sole survivor of the estate's 1931 demolition, the suggested construction date of 1586 for the buildings pictured above places them within the tenure of his eldest son Thomas. Thomas succeeded to the Manor of Easthorne and Well Hall in 1577. On 4 July 1578, he and son William enfeoffed 4 acres called the East Field, this representing the earliest known deed of the Roper Charity.

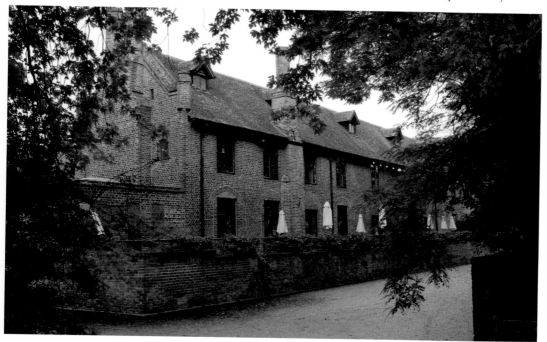

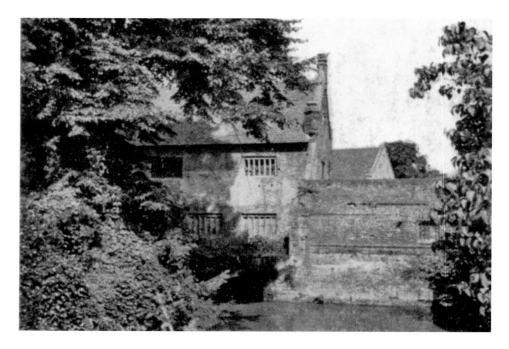

Tudor Barn from the South-East, 1909

The photograph of the old buildings at Well Hall was taken from the Moat Bridge, which connected the manor house with the originally rural lands lying across from its island site. Mainly put to agricultural use in the centuries following its Tudor heyday, cottages providing farmworkers with accommodation were located to the north and south of the estate, along with dedicated service buildings and fenced enclosures, such as the paddock. The Pleasaunce is today directly accessed from the Well Hall Road.

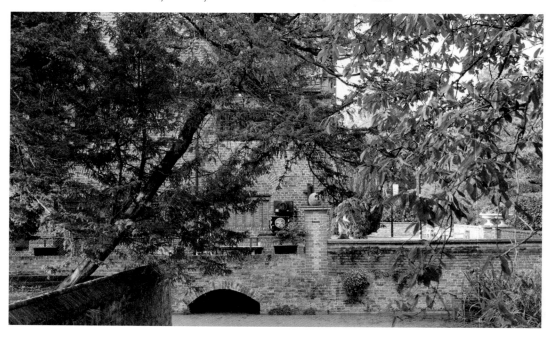

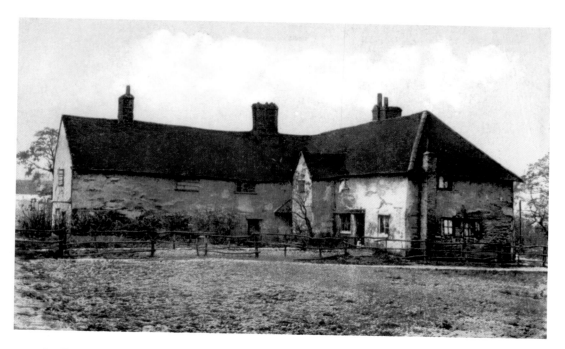

'Nell Gwynne's Cottage', Well Hall, 1908

The romantically colourised postcard above is a companion piece to a photographic version in my collection of a similar date, though pictured from a different angle, more accurately advertised as 'Old Cottages, Well Hall'. With no historical provenance for placing King Charles II's self-styled 'Protestant Whore' in a humble cottage in Eltham, the association is no doubt a sales strategy by the card's publisher. Both versions at least agree that locally dubbed 'Wellcottages' were situated on Well Hall Road.

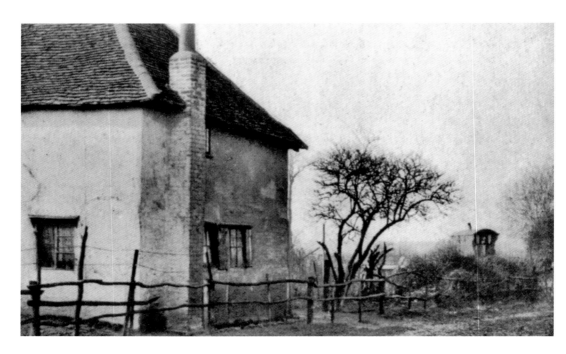

Old Cottage, Well Hall Road, 1909

This alternate view of the same cottage features the field lying beyond, previously obscured by its chimney wall; a caravan may be clearly distinguished, parked between two trees, which provide an artistic frame, at right. This area, past Well Hall on the road to Woolwich, was reputed to have been a resort for caravans for several centuries before the above photograph was taken in the early days of the twentieth century. The cottages have since made way for urban development.

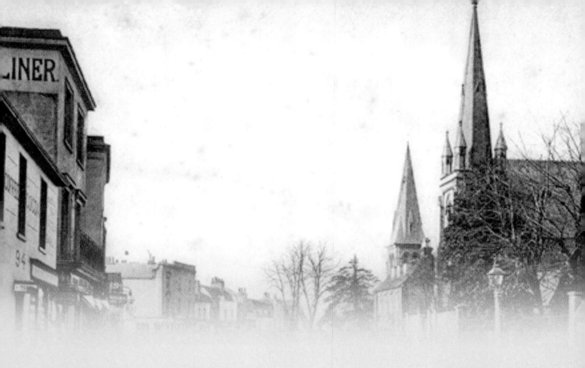

CHAPTER 2

Eltham Village

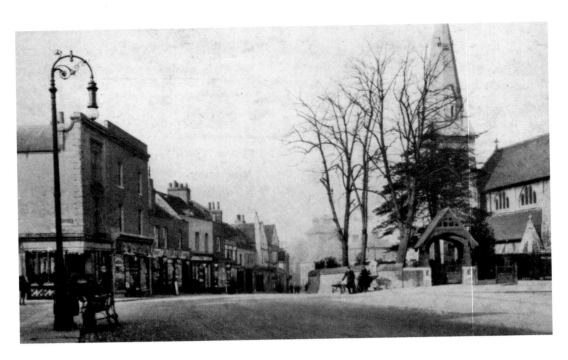

Eltham Village

Until late into the nineteenth century, housing in Eltham was largely confined to the village itself, with isolated farmsteads peppering the landscape beyond. Its combination of unblemished pastoral charm and proximity to London made it a historic magnet for wealthy merchants and gentry to summer here, either leasing spacious lodgings or commissioning substantial houses for private use. Many buildings have been lost to decay and misguided 'improvement', but much still remains, with Eltham now combining ancient beauty and urban modernity.

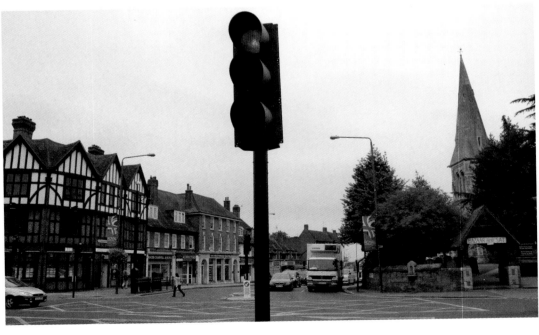

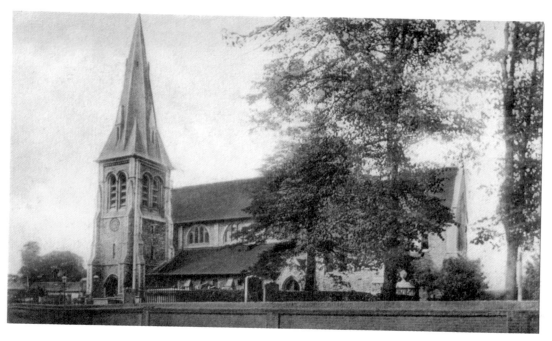

Eltham Church

Dedicated to St John the Baptist, Eltham parish church falls within the diocese of Rochester and deanery of Dartford. It formerly held a memorial to Margaret Roper, daughter of Sir Thomas More, whose husband William bought the rectory of Eltham around 1550, reserving the Advowson of the vicarage when he gifted the Provost and Fellows of Oriel College, Oxford, with the rectory. The Roper family ultimately lost its lease upon failure to renew at the time stipulated in the original grant.

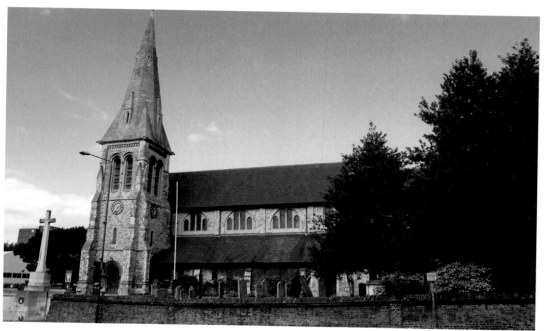

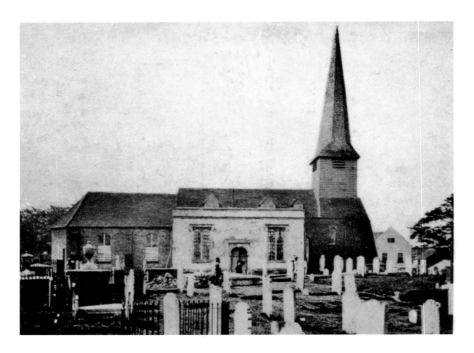

The Parish Church, 1870
The new Gothic structure was erected between 1875 and 1879 on the site of the old church, here pictured from the north. It was demolished in 1873. Its predecessor collapsed, with fitting irony, on the Feast Day of St John the Baptist, 24 June 1667. Parish registers survive from 1583. Dublin-born comedian Thomas Doggett was buried here on 27 September 1721. Despite enjoying great renown and success throughout his stage career, a plaque mounted on the new church exterior records that he died a pauper.

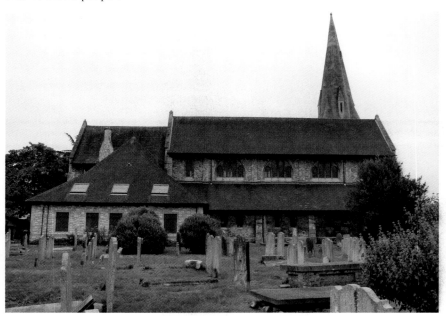

The Old Church, 1860
The first record documenting a church at Eltham dates to 1166, when William, Earl of Gloucester, gave the church of St John to be enjoyed in free and perpetual alms by the church of St Mary and St Paul of Keynsham, upon founding the priory within his manor there. The present church is thus at least the third to stand on this site, retaining the wooden tower and shingle spire of its immediate predecessor at its south-west corner.

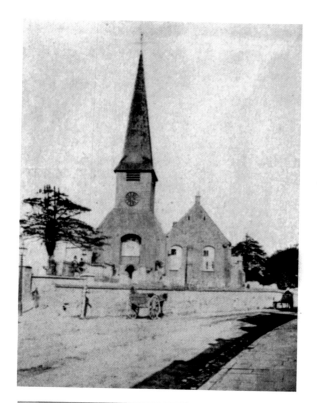

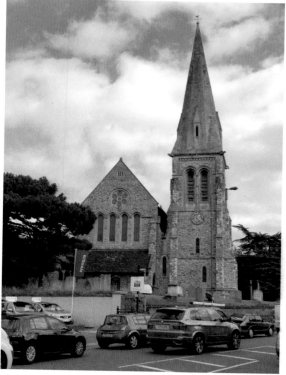

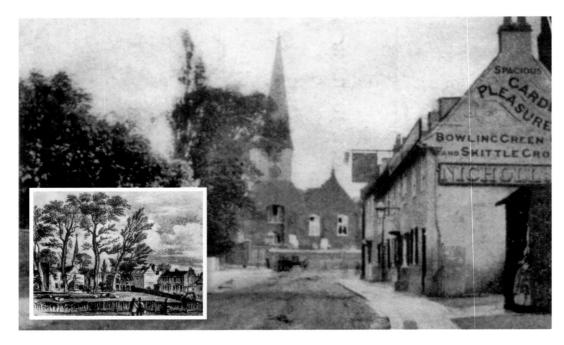

Street Leading to the Old Church, 1870, and the Old Vicarage, 1833 Etching
The old Chequers Inn is visible in both the mid-Victorian shot of the approach to the old church and the Williamite etching of the old vicarage, viewed from what is now Sherard Road. The old tithe barn, which stood between the old church and vicarage, burned down in 1868. The old vicarage was demolished to build houses next to Eltham Brewery, a new vicarage being erected in the old Vicarage Field left of the fence, which is now a petrol station.

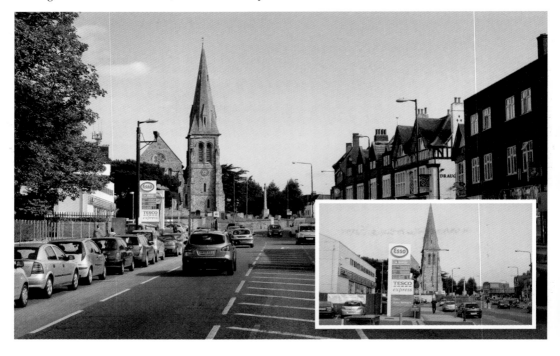

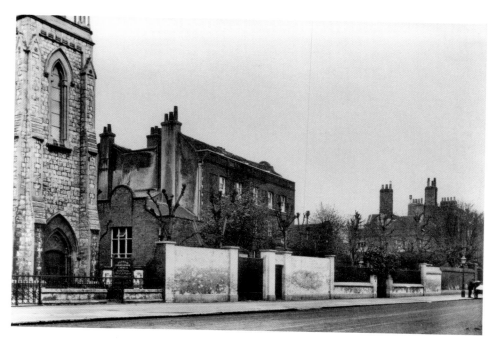

Eltham Congregational Church

The first purpose-built Congregational chapel in Eltham opened on 22 October 1839 in the High Street, where the Arcade stands today. With early workers largely attracted from outlying villages, it was not until Henry William Dobell migrated to Eltham in 1845 that the chapel was transformed from preaching station to home church, at a meeting in October 1846. As enrolment grew, larger quarters became necessary. The new church held its first service on 15 July 1868. McDonald's now occupies this site.

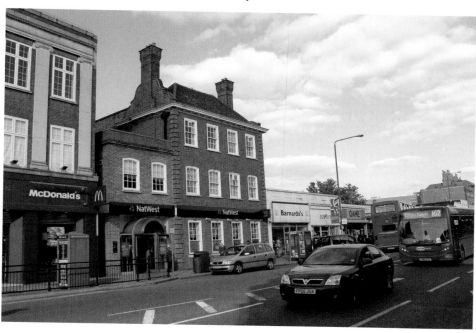

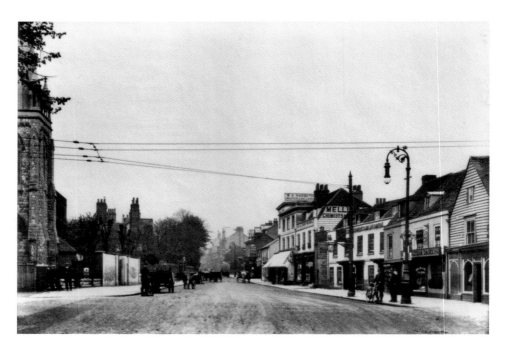

The High Street

With Well Hall Road branching off at bottom left, the Congregational church wall visible on its corner, this early twentieth-century view of the High Street features old-world shopfronts, in pointed contrast to its modern aspect as an urban shopping district. The tempo of life appears relaxed, with two policemen interrupted in conversation in front of the dairy, two boys playing further down the road, and horse-carts ambling toward Bexley – then, as now, the highway linking Kent with London.

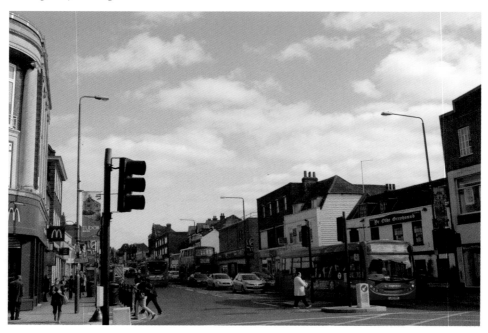

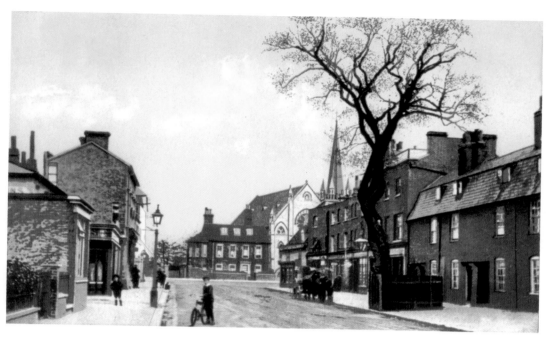

Court Yard, 1910

A distinct component of the courtyard approach to Eltham Palace into which it leads, Court Yard represents the short street running between the Palace lane and Eltham High Street, connecting below its junction with Well Hall Road directly to the left. This was the early epicentre of Eltham Village, the site of its markets and fairs since at least 27 September 1299, when John de Vesci obtained a charter for a market to be held there weekly, on Tuesdays.

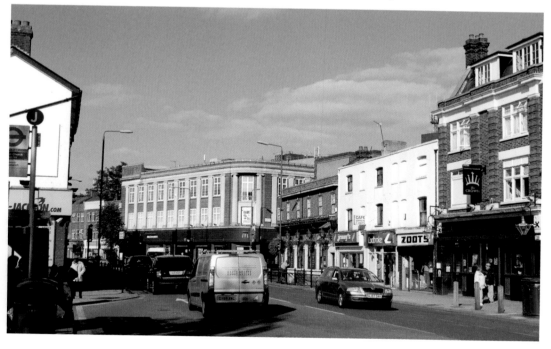

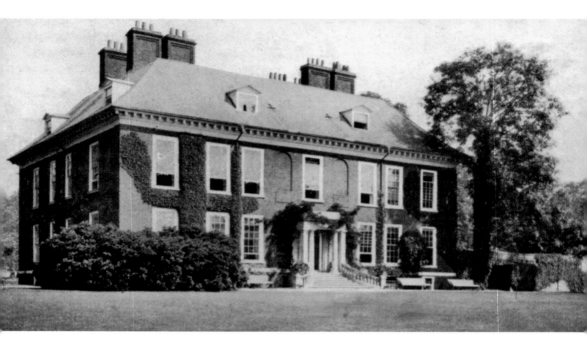

Eltham Lodge

Sir John Shaw, banker to King Charles II, was made Baronet of Eltham on 15 April 1665, having purchased the surviving term of the Manor of Eltham from the Crown in 1663. He erected Eltham Lodge in 1664, as recorded in John Evelyn's diary. It still stands in the Great Park, boasting its original carved staircase, as well as many of the original ceilings and fireplaces. Since 1923, it has been the clubhouse of the Royal Blackheath Golf Club.

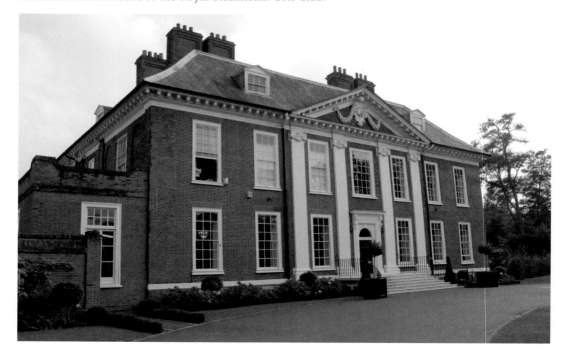

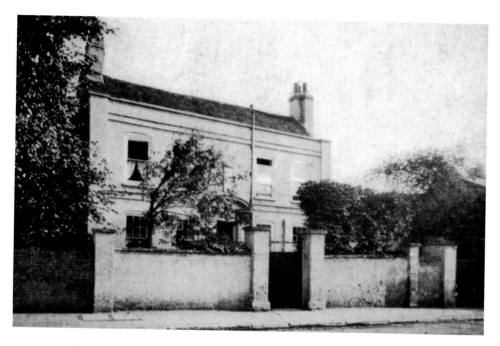

Queenscroft, *c. 1909*

Situated on the High Street opposite Sherard Road, just below their junction, Queen's Croft would be four centuries old if it still stood today! Although it has not been possible to confirm the exact date, it was probably demolished in 1932 when the High Street was widened, one of many sacrifices to Eltham's escalating need for an efficient transport system to service its expansion as an urban town centre.

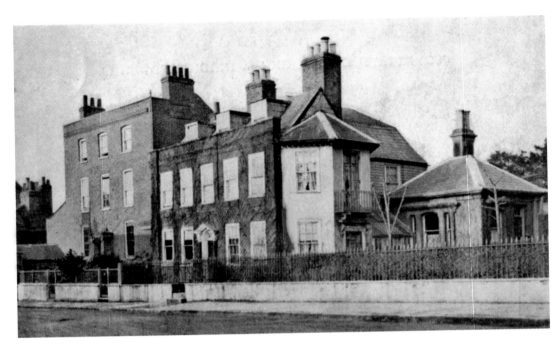

King's Dene, *c.* 1909

The house known as King's Dene stood on the corner of the High Street, where it joins Sherard Road on its western side. The old vicarage once occupied the eastern end, demolished to make room for residential housing during the late nineteenth century. The area sustained significant damage during the Second World War: a V2 rocket impacted Sherrard Road at 8.41 a.m. on 14 November 1944, creating a 38-foot by 9-foot crater, killing eight, and injuring ninety-two.

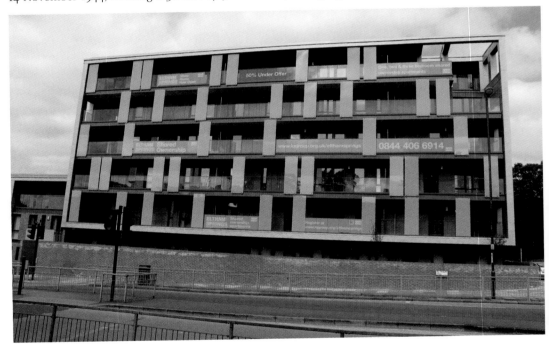

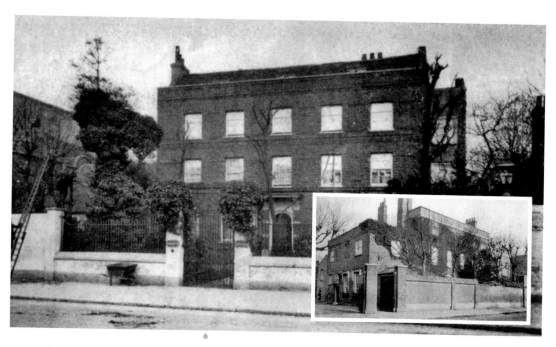

Sherard House and Merlewood, *c.* 1909

Built in 1634, Sherard House stood next to the Congregational church in the High Street, and was home to Henry William Dobell, who demolished his coach house and stables to provide the church's site. It took its name from an earlier resident, botanist Dr James Sherard, author of *Hortus Elthamensis*, who purchased the property in 1719/20. Merlewood stood to the right of Sherard House, its construction dating to the eighteenth century. Both houses and the church were demolished in 1936.

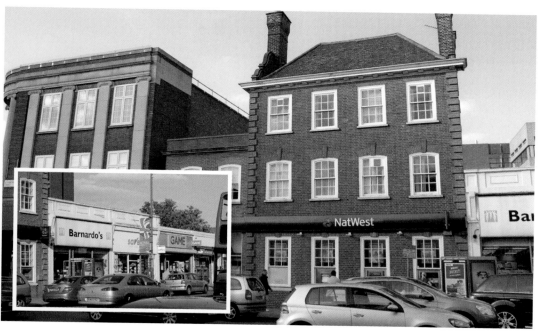

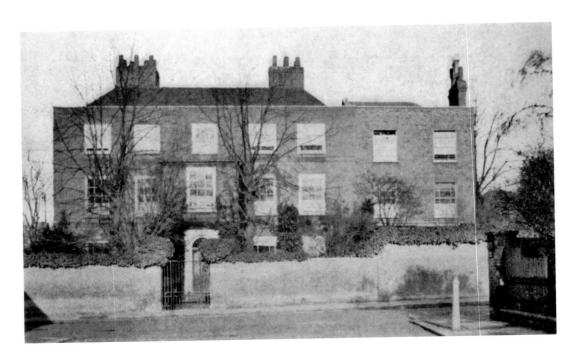

Cliefden House, c. 1909

Comprising Nos 97–101 High Street, Cliefden is an early eighteenth-century three-storey house with parapet front, granted Grade II listed status in 1954. Built around 1720, its interior staircase dates to the early 1600s, and a first-floor panelled door with strapped hinges dates to the 1500s, as does a moulded oak doorframe on the second floor. Stables to the north of the house were likewise built around 1720, incorporating a chimney stack with two diagonally set shafts dating to the early 1600s.

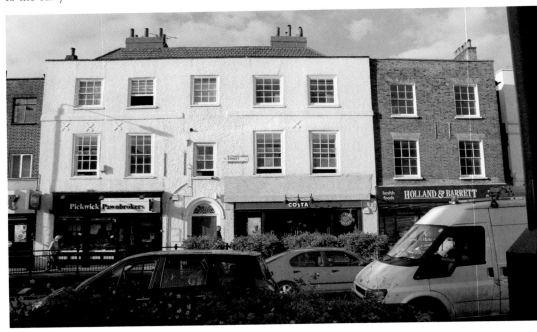

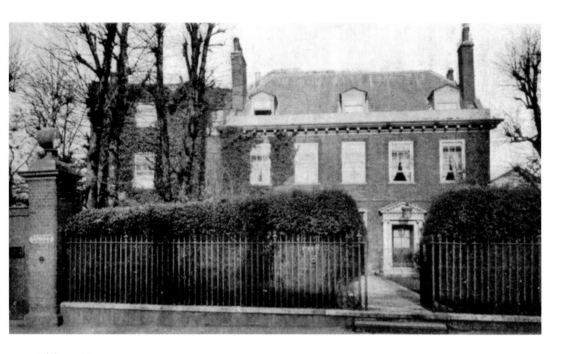

Eltham House, *c.* 1909

The plot opposite Cliefden provided the site for Eltham House, demolished and replaced by shops in 1937. Its sole surviving remnant is the separate red-brick orangery, which, like Cliefden, was granted Grade II listed status in 1954. Regrettably, red-brick walls associated with the garden house appeared in Eltham's 'Heritage at Risk' catalogue in 2010 despite the listing, and their ownership was attributed to the adjoining Presbytery. Both Eltham House and its orangery were built during the late seventeenth to early eighteenth centuries.

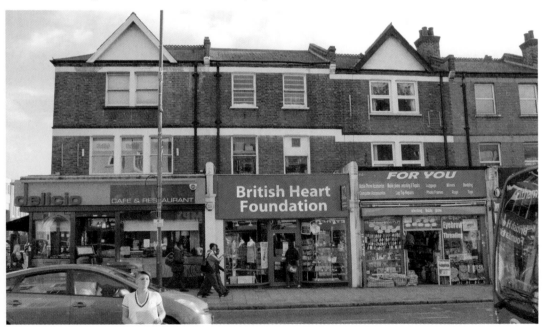

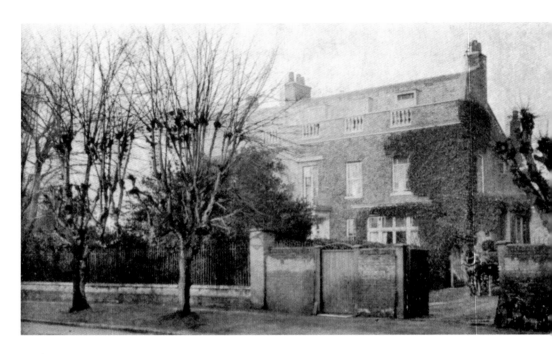

Eagle House, c. 1909

The nineteenth-century edifice of Eagle House stands next to Christ Church Presbytery at No. 229 High Street, facing Victoria Road. The two properties united to a shared purpose in 1910, when the Canons Regular of the Lateran purchased Eagle House, rechristening it Christ Church Priory. Although the church was completed on 23 February 1936, it remained unconsecrated until 9 November 1981. Christ Church Priory is part of the Roman Catholic parish, which falls within Greenwich deanery, and the Archdiocese of Southwark.

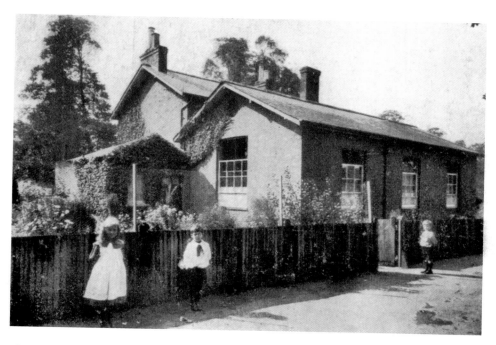

The National Infants' School, 1909

Established in 1840, the National Infants' School originally shared the site already occupied by the National School at the end of Pound Place, adjoining Back Lane. One rood, 8 pecks of land in East Lane, Eltham, was granted in December 1851 to the use of an infant school for the parish poor, and residence of a schoolmistress. Back Lane has since been rechristened Philipot Path, the school having made way for Sainsbury's, whose shopping trolleys line the wall where children once stood.

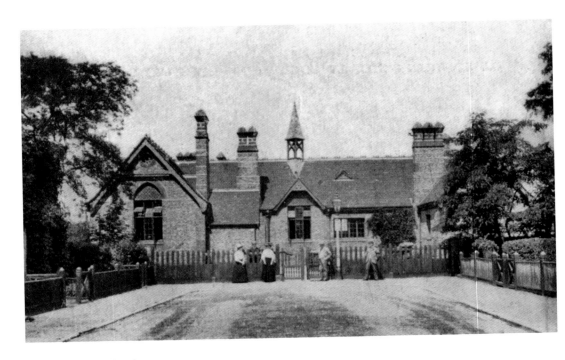

The National Schools

Established in 1814, when its first master was paid £20 yearly for the tuition of twenty boys, Eltham's National School was subsidised during its early days by Legatt's Charity, Mrs Elizabeth Legatt having bequeathed property rents in 1714 for teaching poor children 'to read, write, and cast accounts', and learn 'the catechism, liturgy, and doctrine of the Church of England'. The school building on Roper Street was erected on part of the 4-acre field that formed part of the Roper Charity.

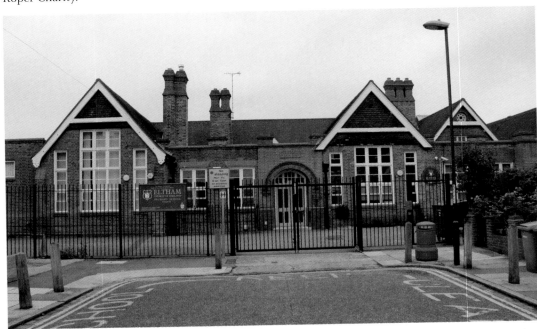

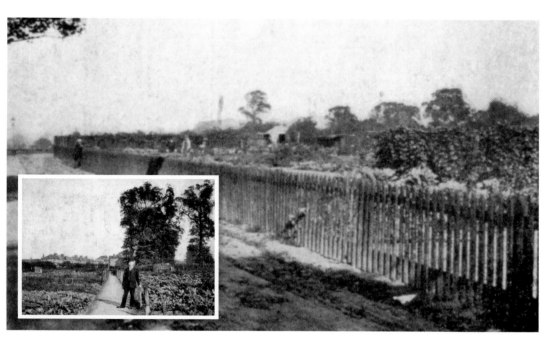

The Old Lane by the National Schools and 'One Acre Allotments', 1908

Woolwich Lane, running along the east side of the National Schools, is pictured above shortly before its redevelopment into the thoroughfare now called Archery Road. Originally a farm track, it branched onto an ancient public right of way, one footpath leading to the field at the top of the school, which was entered through a stile. The allotments to its right stood on a meadow known as 'One Acre', a grazing post for herds shepherded from Kent to the markets of London.

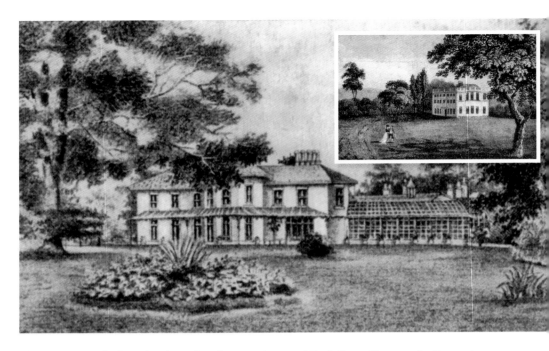

The Roman Catholic School, Undated Engraving, and Park Farm Place, 1785 Engraving
Eltham's Roman Catholic School was built on the site of Park Farm Place, once home to Commodore Sir William James, in memory of whom Severndroog Castle was erected in Oxleas Wood, Shooter's Hill. Sir William settled in Eltham in 1759, purchasing the mansion in 1774. He continued to live there until suffering a fatal stroke in December 1783. Eventually joined with Eltham Park estate, the property was bought by Archibald Cameron Corbett, who redeveloped it as suburban housing between 1900 and 1914.

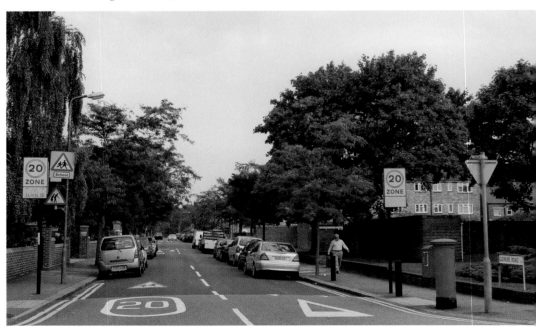

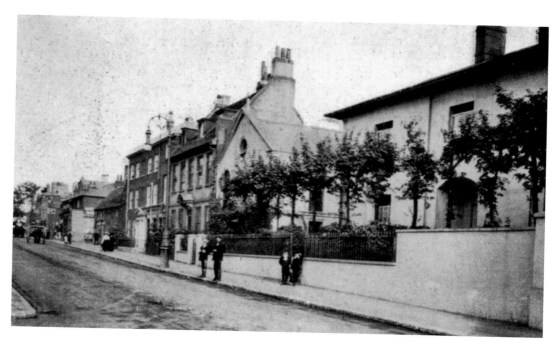

St Mary's Orphanage

In 1870, the house earlier known as Torrington Lodge was opened under the Sisters of Mercy as an Industrial School for girls, with a Poor School next door. The Lodge, with St Mary's convent, was converted into a hospital orphanage run by the sisters in 1888. It was transformed in 1928 into St Mary's (Day) School. Requisitioned by the Civil Defence during the Second World War, the building was used as Eltham Rescue Service HQ. It is now St Mary's community centre.

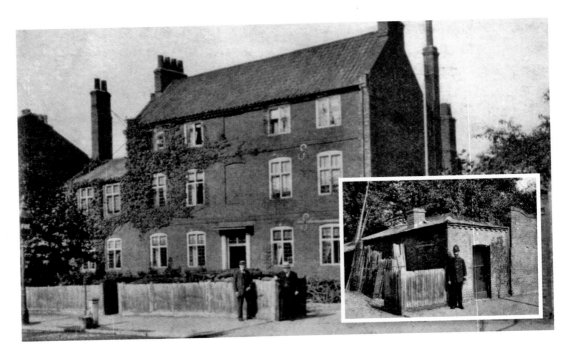

The Old Workhouse and the Old Lock-Up

The parish workhouse was built in 1738 at Blunt's Croft, then comprised of 1 acre and 2 roods of meadowland, and is now subsumed into the High Street. According to a Parliamentary report dating to 1776/77, later published under the title *Abstracts of the Returns Made by the Overseers of the Poor*, Eltham's workhouse housed thirty-six inmates. The nearby 'cage' or 'lock-up', below the south-western corner of Eagle House's garden, accommodated spill-over from the new police station, which was opened in 1865.

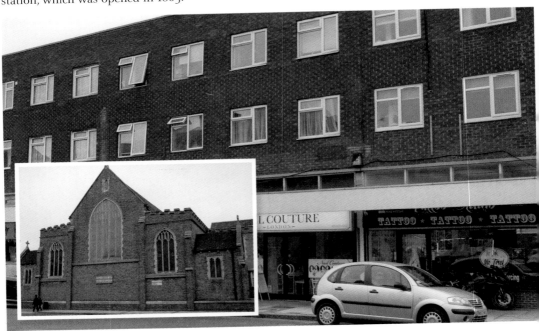

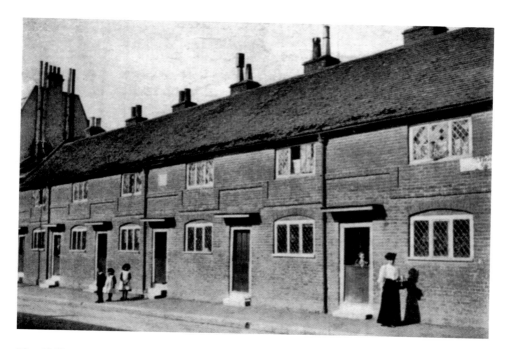

The Philipot Almshouses

Also erected on Blunt's Croft, the almshouses were funded by the substantial bequest left by Thomas Philipot in his will dated 11 September 1680. The Philipot Charity was founded in 1682; its first six tenements were built in 1694 at a cost of £302 to accommodate four poor inhabitants of good character from Eltham and two from Chislehurst, with a yearly stipend of £5 for each. As the trust grew, further building took place in Blunts Road and Roper Street.

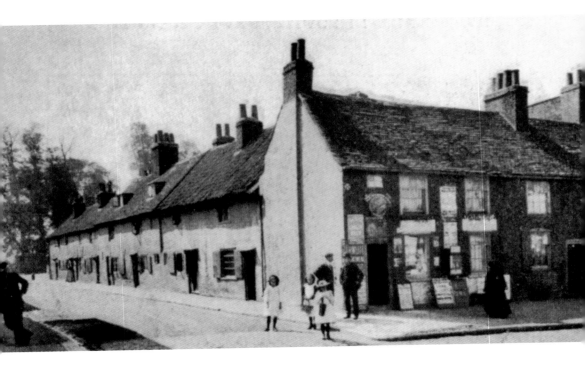

Pound Place, 1909

Once featuring a row of late seventeenth- and early eighteenth-century cottages, Pound Place takes its name from the old police station pound, formerly situated at the south side of the High Street, opposite the public library. Its aspect is unrecognisable today: no longer residential, but a focus for local shopping and dining. Regrettably, the cottages were demolished in 1929.

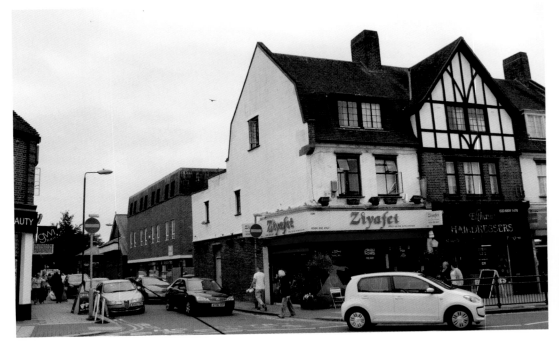

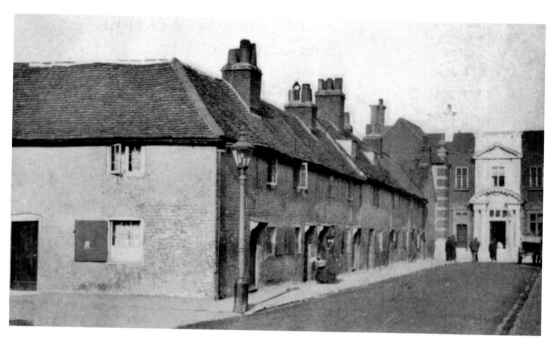

Pound Place

The public library is visible on the High Street in the distance, as viewed from Pound Place, in the image above. Its construction was largely financed by Andrew Carnegie, the American philanthropist, who originally envisaged it as the centrepiece for a substantial civic complex, which remained unbuilt. Designed by Maurice B. Adams in the style of the English Renaissance, the library opened in 1906, and was accorded Grade II listed building status on 10 November 2000.

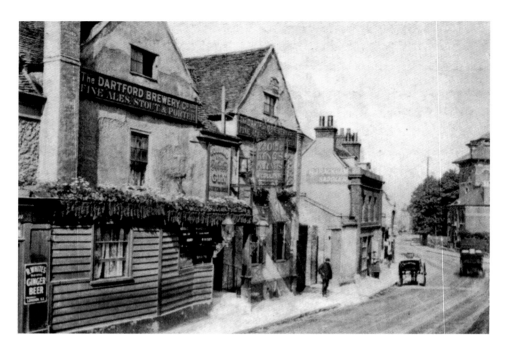

The Old King's Arms Inn

Now demolished, the King's Arms stood at No. 60 High Street. William Goodwin was its proprietor from at least 1822, when he was recorded in the parish registers as an innkeeper at his son's baptism. He was entered at this address in the Post Office Directory through to 1874. The inn was known for its parlour fireplace, 'as well as the ancient clock, the old bacon rack, and the distinct air of antiquity which all the rooms wear'.

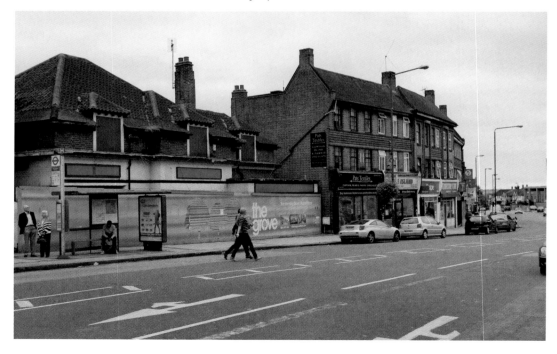

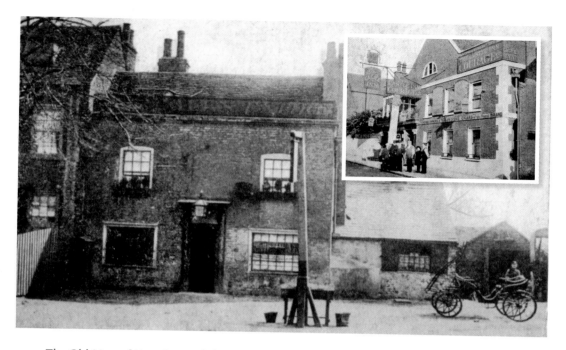

The Old Man of Kent Inn and the Old Castle Hotel

Sitting at the corner of the High Street, adjoining the old fire station, the Man of Kent's ornate façade dates to 1888, and was restored in 1998. It became a 'lost pub' around 2011. The old Castle Hotel was pulled down and rebuilt during the 1910s on its site at No. 108 High Street, originally having operated as a posting house. Two tokens survived, dating the earlier building to the mid-seventeenth century, with a contemporary value of one farthing each.

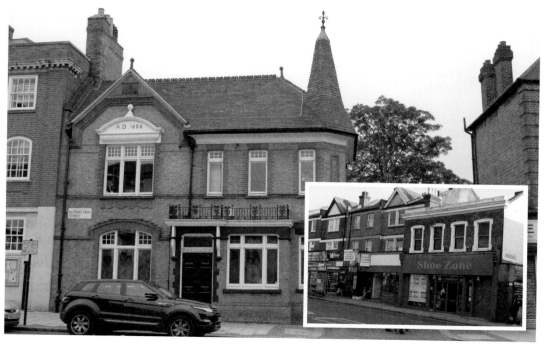

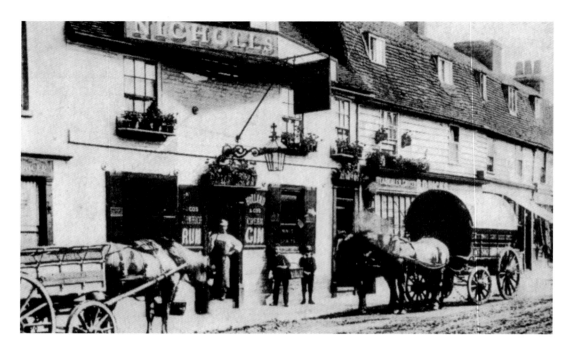

The Old Rising Sun

Still operating as a pub today at No. 189 High Street, the then *c.* 200-year-old Rising Sun was rebuilt in 1904, when the Old Sun Yard housing the workshops of Messrs Smith, coachbuilders, the smithy standing to the west, and a row of wooden cottages running behind the inn were lost, condemned by the local authorities, and their inhabitants scattered. During the early days of the Congregationalist community, members met in a separate wooden building located at the end of Sun Yard.

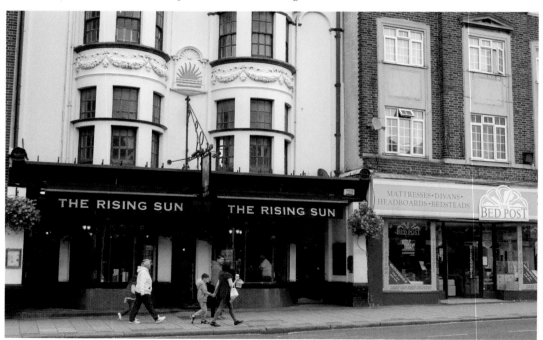

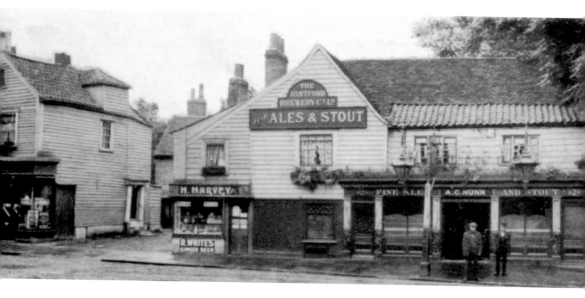

The White Hart, 1909
Situated at No. 2 High Street, the inn was rebuilt in 1904, the year Thomas John Marshall was listed in Kelly's Directory as beer retailer at the White Hart. Marshall was among those who tragically lost their lives at the Somme in 1916. A former Chequers pub, it now operates as a carvery and steakhouse under the same name.

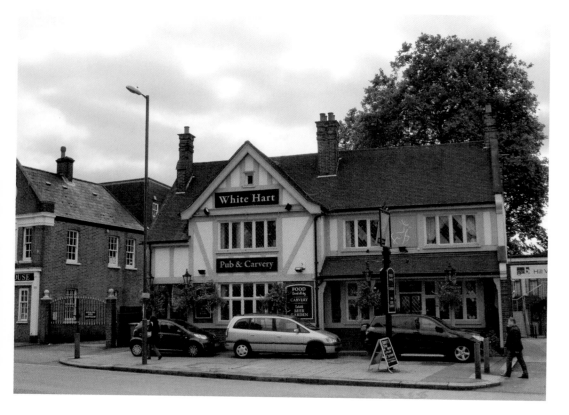

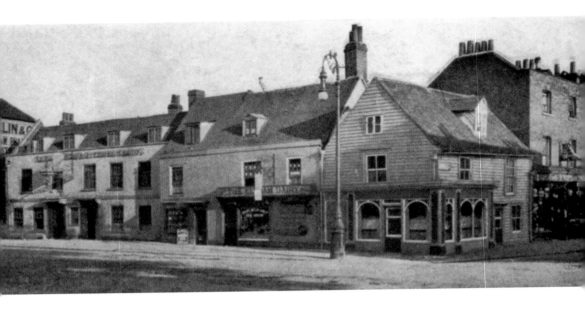

The Greyhound, 1909

Later re-dubbed 'Ye Olde Greyhound', the exterior of the inn situated at No. 86 High Street has been restored to its *c.* 1720 appearance, refurbished in 2005, only to become a 'lost pub' a year later. It has since been reinvented as a curry house in the Yak and Yeti chain of Nepalese restaurants, its run-down interior modernised, with sympathetic preservation of its old wooden features and charming external façade.

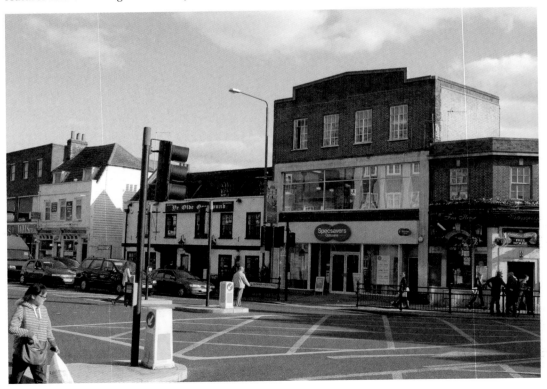

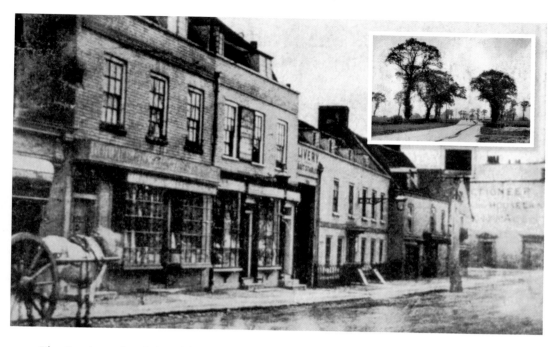

The Greyhound and the Old Woolwich Road, 1896

Thomas Tilling's horse bus was stabled at the rear of the Greyhound Inn, its service connecting the villages of Eltham and Blackheath until 1908. The Old Woolwich Road, running north from the High Street at its junction with Court Yard to the south, is today known as Well Hall Road. It was while waiting for a bus here in 1993 that eighteen-year-old student Stephen Lawrence was fatally stabbed by five youths in a racially motivated attack. A roadside memorial commemorates the tragedy.

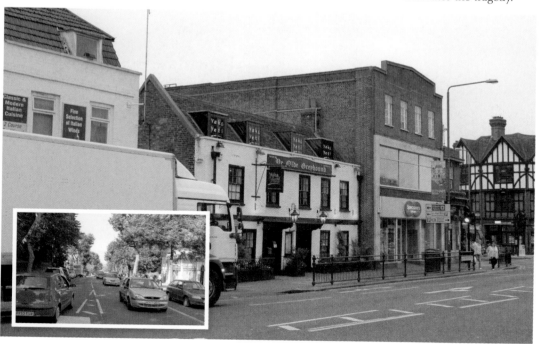

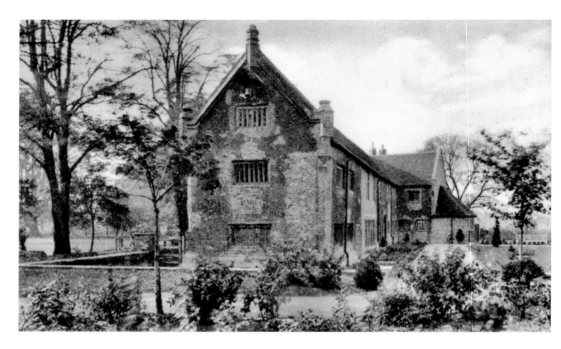

The Tudor Barn, Well Hall

Sole surviving edifice of the Roper estate at Well Hall, the Tudor Barn has been fully restored, its interior sympathetically converted to a bar and restaurant, and appointed Grade II listed building status. Under prior management, it provided the venue for the local folk music club, which plays regular sessions and hosts 'singarounds'. Folkmob's current home is the Blackheath Rugby Club at Well Hall, today's attire somewhat more casual than that of yesteryear's traditional handbell ringers, as pictured on the following page.

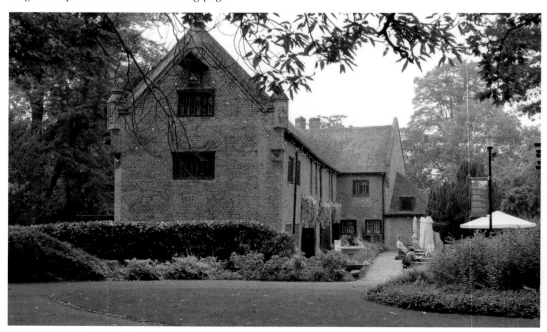

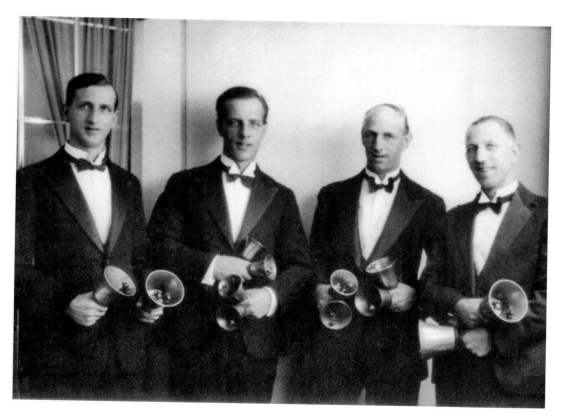

The Brett-Smith Brothers and Players at the Tudor Barn

Jack (d. 1931, not pictured), Percy, Tom, David, and Cyril Brett-Smith were taught the art of handbell ringing by their father Robert Brett (1870, Stanstead, Suffolk–1935, Chislehurst, Kent), said to have acquired the hyphenate Smith due to a clerical error when registering his marriage to wife Harriet. Robert worked in munitions at Woolwich Arsenal from the outbreak of the First World War in 1914. The autograph on the back of the photograph above places the family band in Eltham during the 1930s.

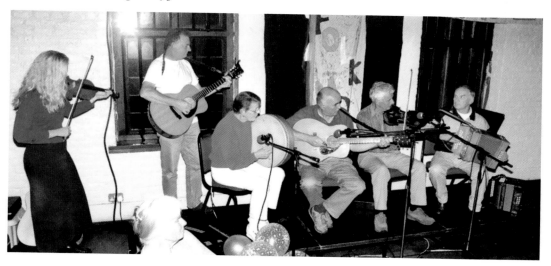

Well Hall, from the Station

Well Hall railway station was opened on 1 May 1895. Although Eltham had nominally had its own station since 1866, it was located some distance away in Mottingham, and was appropriately rechristened as Mottingham in 1927. Eltham Well Hall was located 200 yards west of today's station (opened in 1985). It was first replaced by Eltham Park station, 700 yards east, on 1 May 1908, with villagers now able to travel to London without first taking the bus to Blackheath.

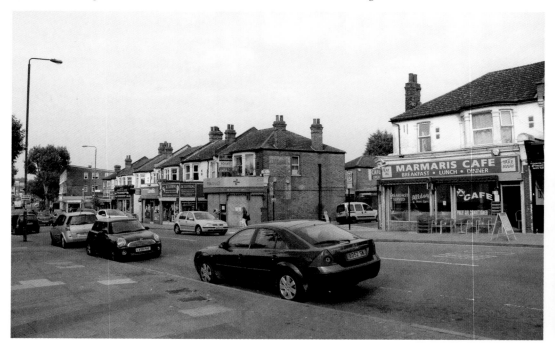

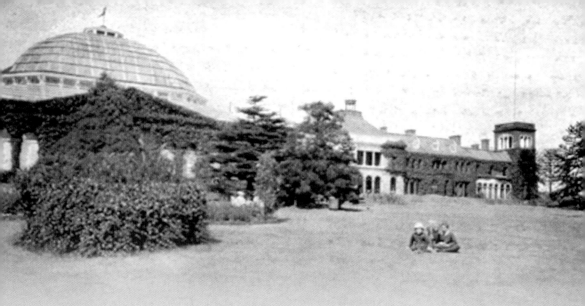

CHAPTER 3

Avery Hill to
New Eltham

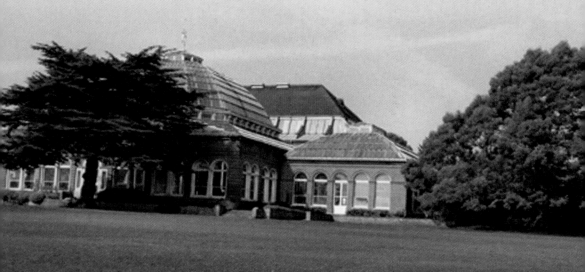

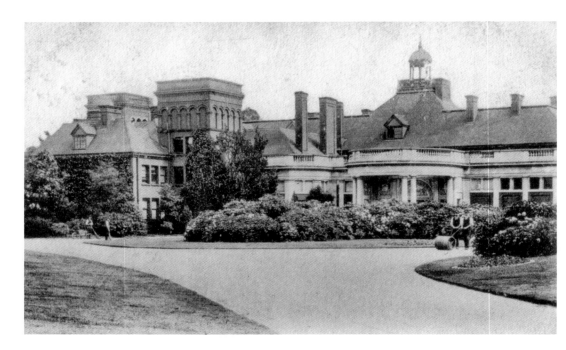

Avery Hill Mansion, 1905

Col. John Thomas North (1842–96), dubbed 'the nitrate king' for the fortune he amassed dealing in Chilean sodium nitrate, spent much of his great wealth in building the mansion house at Avery Hill, dying only five years after its completion. The building and surrounding 86 acres of land were bought by the London County Council in 1902, which opened Avery Hill Park to the public in 1903. The house was internally redeveloped as a teacher training college for schoolmistresses in 1906.

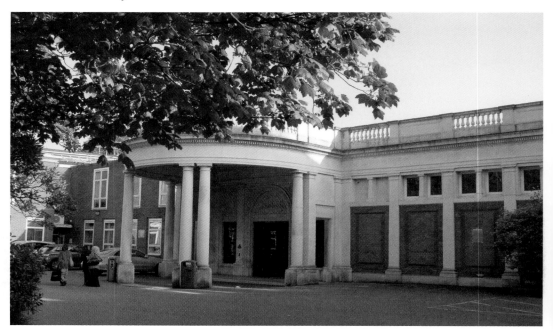

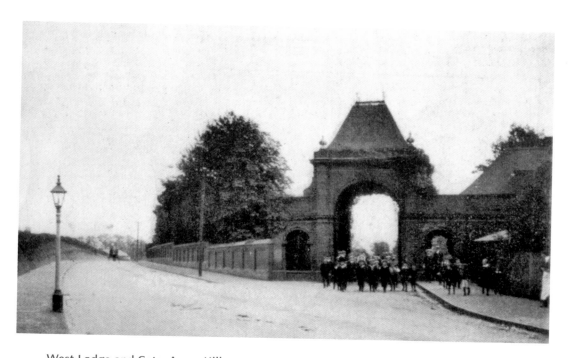

West Lodge and Gate, Avery Hill, *c.* 1909
Avery Hill Training College became a Grade II listed building on 8 June 1978. Its picturesque gate, with attendant West Lodge, now forms the main entrance to its campus, the East Lodge lying at the park's entrance on Bexley Road. Opened in 1906 as the first residential college for women operated by a local authority, men were at length admitted in 1959. Avery Hill was amalgamated into Thames Polytechnic in 1985, and is now part of the University of Greenwich.

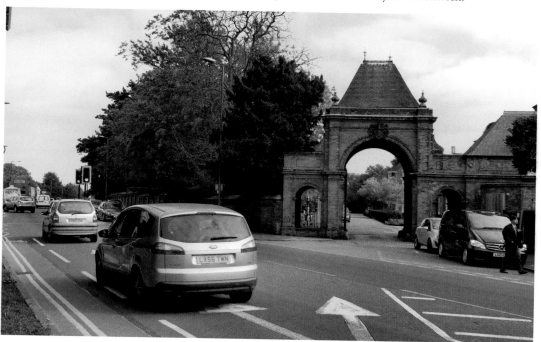

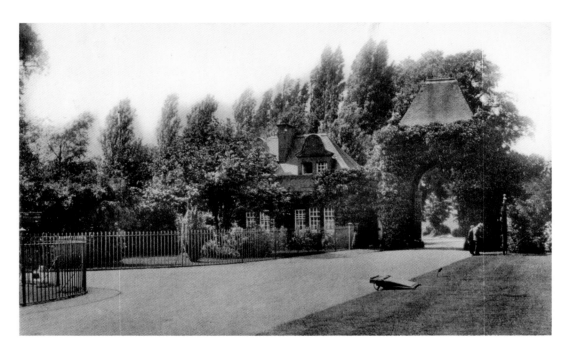

West Lodge, Avery Hill, 1912

Profits from Greenwich Council's sale of the West Lodge, coupled with insurance proceeds, financed the opening of a new café in Avery Hill Park five years after the arson attack that destroyed its original coffee bar in 2005, following persistent acts of vandalism. The campaign to rebuild was orchestrated by the Friends of Avery Hill Park, an organisation dedicated to beneficial improvements for the local community, as well as historic preservation of the site itself.

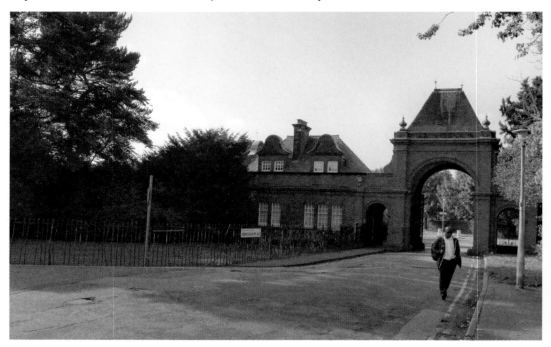

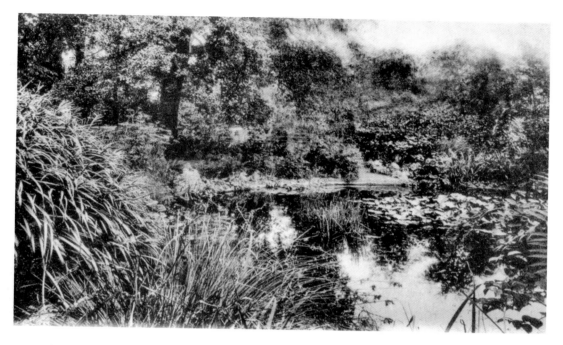

The Pond, Avery Hill, 1908

The public park at Avery Hill still features remnants of its formal gardens, though decorative ponds have largely given way to grassland, and a rockery. To achieve his desired layout, Col. North found it necessary to divert the avenue, which originally ran closer to the mansion, demolishing an old farmhouse that stood in the path of the alternate roadway he constructed, running from the bottom of Lemon Well Hill to Bexley Road's junction with White's Cross.

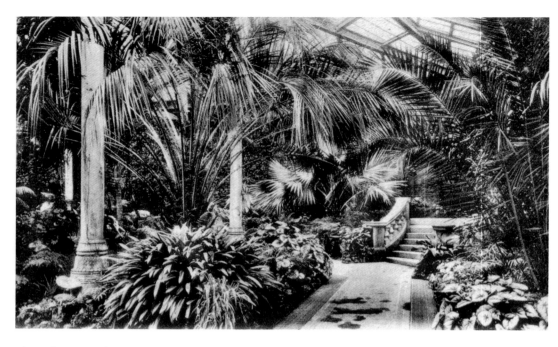

The Winter Gardens, Avery Hill College, 1914

Col. North created his domed hothouse to accommodate the tropical plants brought home from his travels. It was opened to the public as part of Avery Hill Park in 1903. Having suffered massive damage during the First World War, it was not until 1962 that the Winter Gardens reopened, following extensive refurbishment. They reopened a second time in 2010, following temporary closure for standard conservation and restoration, with replanting of the conservatory to include exotic flora from Chile, reflecting Col. North's original collection.

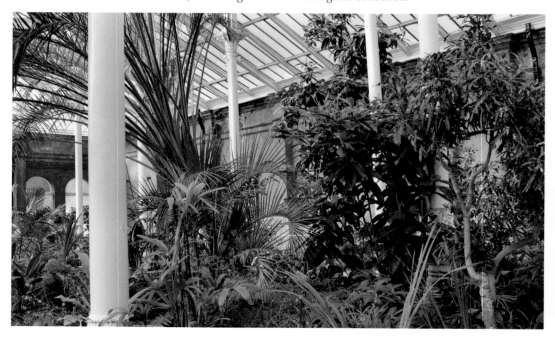

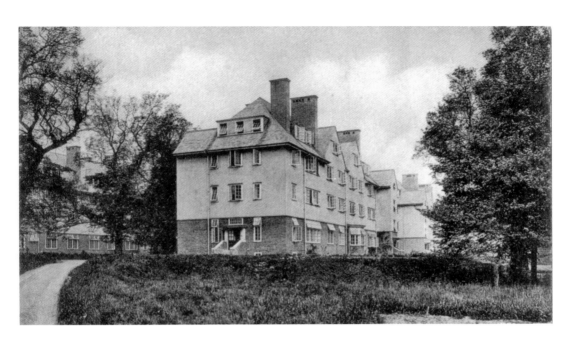

Charlotte Brontë Hall

Identified as Brontë Hall in a near-identical photograph dated around 1930, this now rebuilt residence provided student housing during Avery Hill's days as a teacher training college. Its name does not reflect any personal association of the famous author with Avery Hill, or outlying Eltham. It is, however, a unique literary nod for a campus whose other buildings honour female pioneers, such as Elizabeth Fry and Mary Seacole, along with six courts named after the wives of Henry VIII.

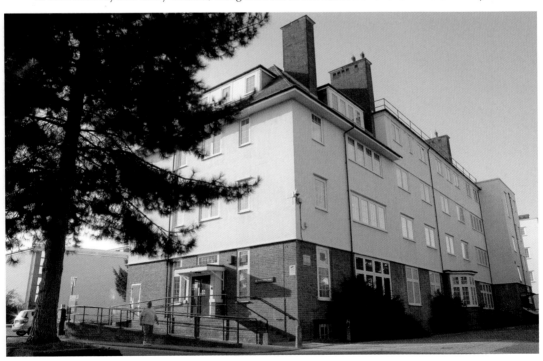

Barn House, *c.* 1909

Pippenhall, a seven-storey block of flats plus four-storey units at the junction of Bexley Road and Southend Crescent, was erected in 1960, despite local protest, on the site once occupied by Barn House (*above*) and neighbouring Conduit House (*p. 73*). Both properties had been purchased by Sir William James, memorialised by Severndroog Castle, in 1780. The garden at Barn House was renowned for containing a sundial fixed on a pedestal made from one of the balustrades of the old London Bridge.

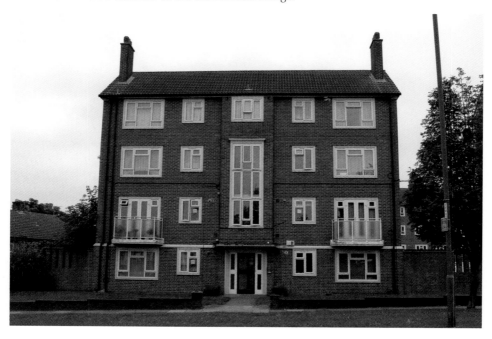

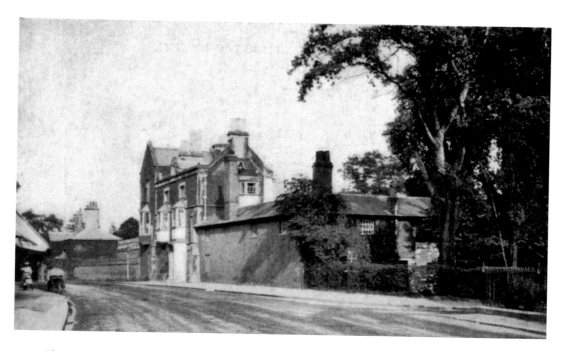

The Road to Bexley with Conduit Lodge, *c.* 1908

The name Conduit Lodge, otherwise Conduit House, commemorates its position on grounds attached to the ancient Conduit Head channelling spring water from the Warren, under the Golf Links north of Bexley Road, to Eltham Palace and its moat, by means of wooden pipes. A clause within an old Crown lease entailed responsibility to maintain the conduit to the tenant of the house. The Head, which probably dates to the sixteenth century, appeared on Eltham's Heritage at Risk list in 2010.

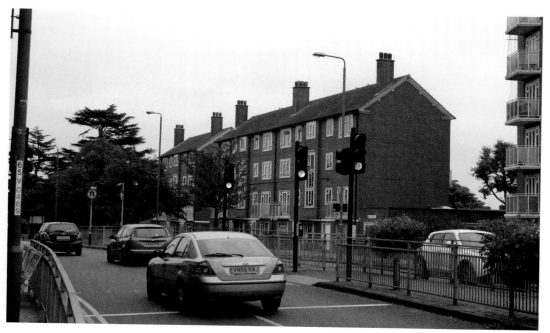

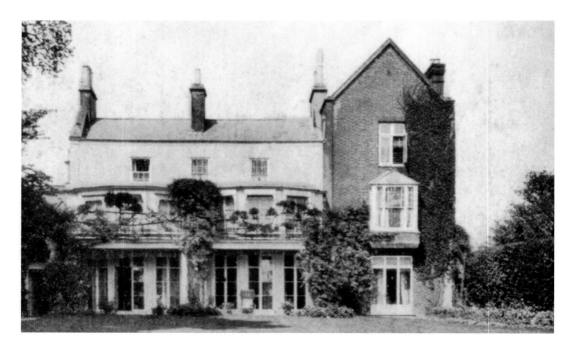

Conduit House, *c.* 1909

One tenant of note was Lady Rancliffe, daughter of Sir William James. Her father died suddenly during the festivities marking her upcoming marriage to Thomas Boothby Parkyns, later 1st Baron Rancliffe, in 1783. She, too, tragically died young, and was buried aged thirty-one at Eltham parish church on 28 January 1797. Early photographs reveal that Conduit House was a three-storey building, and an auction sale map dated 1852 survives, providing a basic ground plan for both the interior and gardens.

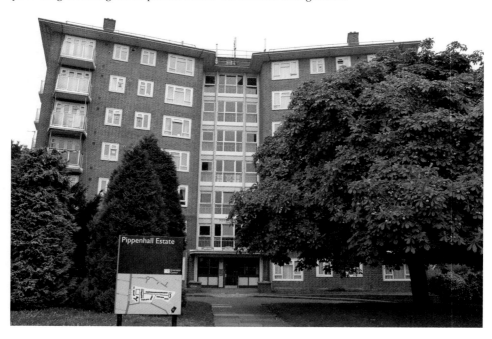

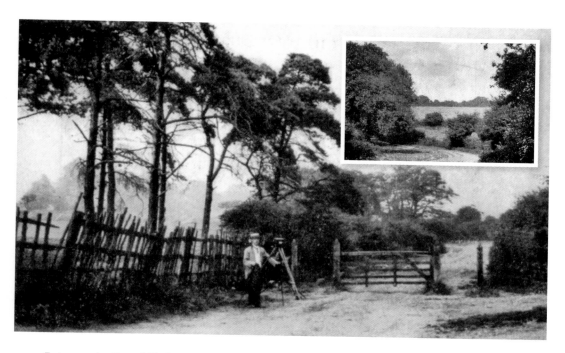

Entrance to Gravel Pit Lane, 1909, and a Bit of Gravel Pit Lane, c. 1908
Branching north from Bexley Road, east of the Warren Golf Links, Gravel Pit Lane now forms part of the Green Chain Walk, a network of pathways in south-east London. The grounds were originally known as Warren Field, the name referencing its identity as a rabbit warren, unsuitable for cultivation. Eltham Golf Club became subtenants of the Crown's leaseholder soon after its formation on 7 May 1890, with an initial membership of eight. Its annual rent for 17 acres was £10.

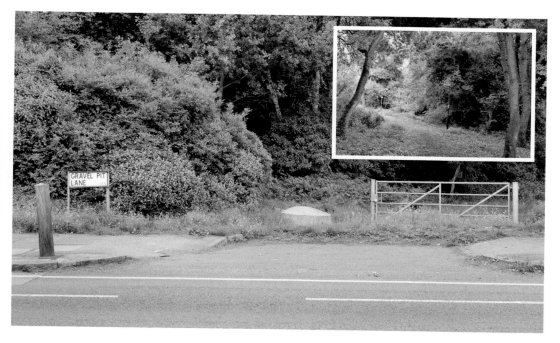

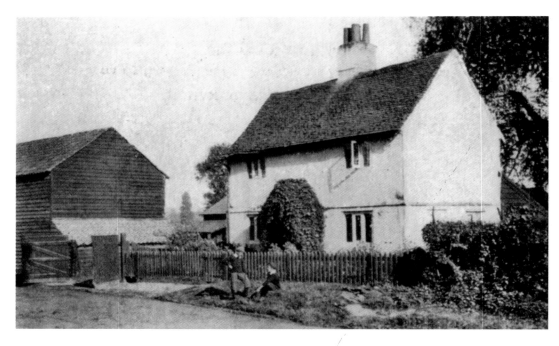

Pippen Hall Farm, *c.* 1909
The site once occupied by Pippen Hall Farm, south of Bexley Road between Eltham and Avery Hill, is today used for allotment gardening, with plots having been rented out by Woolwich Council since the 1950s. Now managed by Greenwich Council, the area contains fifty plots and a shop run by the Eltham & Avery Hill Gardens Society. The fields of Pippen Hall Meadow were subsumed into the Avery Hill estate during the 1890s, and are today used as riding stables.

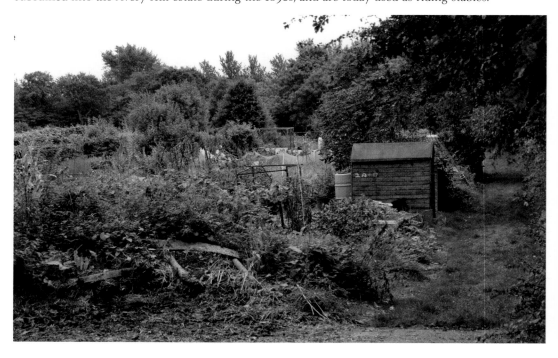

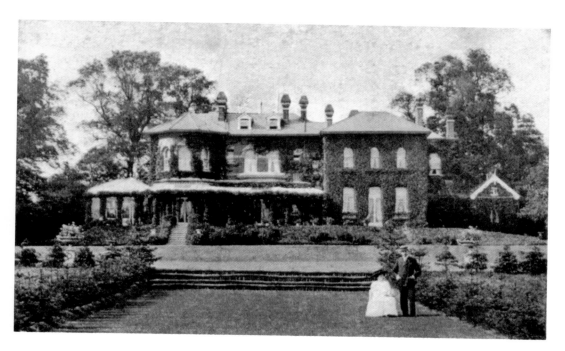

Lemon Well, *c.* 1909

Situated east of Pippinhall Farm and south of Bexley Road, Lemon Well House represented a comparatively new building in old Eltham, before its replacement by suburban housing. It shared its grounds with the spring that supplied nearby Lemon Well, a brick fount on the wayside whose waters were locally famous for their medicinal properties, particularly associated with healing afflictions of the eyes.

Pole-Cat End, 1909

Spelled Pollcat End in a map dated 1805, reflecting the area's rural origins, Pole-Cat End represented both the vicinity of Southwood House, where the roads to Lamorbey and Pope Street branched in opposite directions, and the residence's original name. Southwood House itself was purchased by the London County Council, which converted it into a hostel to accommodate students at the Avery Hill Teacher's Training College in 1908.

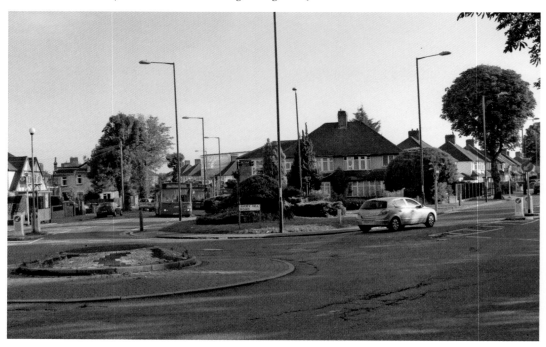

Forest Lodge, New Eltham

New Eltham was created through the suburban development of farmland south of Eltham Village, centring on the hamlet and crossroads of Pope's Street, after which its new railway was initially named in 1878. The station was officially rechristened New Eltham in 1876. Itself later demolished, Forest Lodge was erected on a site formerly occupied by The Black Boy wayside inn, near Pole-Cat End on the parish boundary, its own name once again reflecting the rural origins of the district.

Southwood Road East, New Eltham

Now called Avery Hill Road, Southwood Road East forked south from the Bexley road, running down the length of Avery Hill Park past Pole-Cat End, and curving west into New Eltham, whose railway station lies above its junction with Foots Cray Road. There it became Southwood Road West, before terminating at the north-west corner of the Belmont Park Golf Links. The terraced row pictured above answered the growing need for comfortable, affordable housing within the emergent community.

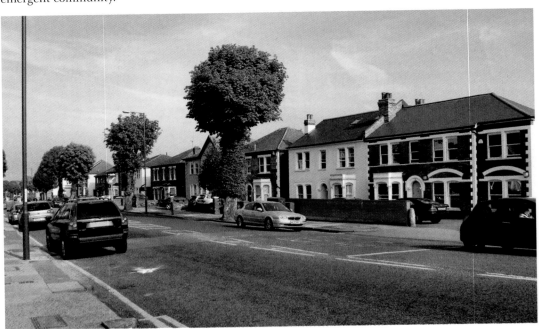

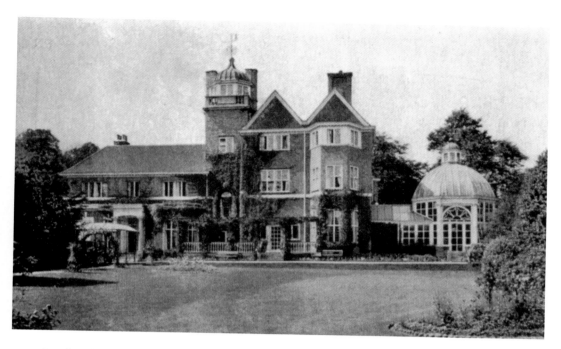

Southend Hall, *c.* 1909

The Edwardian edifice of Southend Hall, as pictured above, stood on the site of a Victorian farmhouse with a substantial acreage, garden, and pond, according to a tithe map dated 1839. From July 1940, the hall became HQ for the 21st County of London (Eltham) Battalion Home Guard, used for both accommodation and training, with a rifle range set up to the rear of the drill hall. The residence has since been demolished, its location now occupied by Inca Drive.

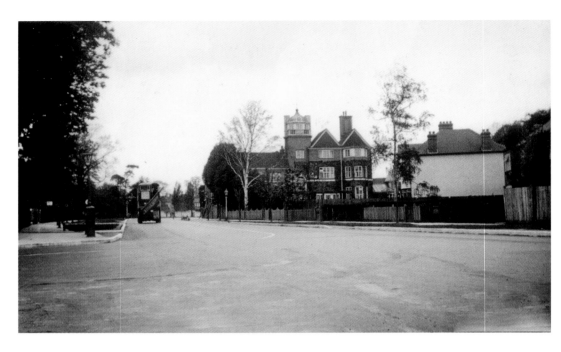

Southend Hall, Foots Cray Road

Deriving its name from Godwin Fot, a Saxon landowner assessed in the Domesday Book, and the River Cray, which passes through the village, Foots Cray Manor was situated in the midst of other estates, including Eltham. Both were held by Odo, Bishop of Bayeux, with Eltham containing four and a half times more households. Today, it falls within the London Borough of Bexley. Foots Cray Road runs through the heart of New Eltham, where it was originally dubbed Pope Street, after the surrounding rural settlement.

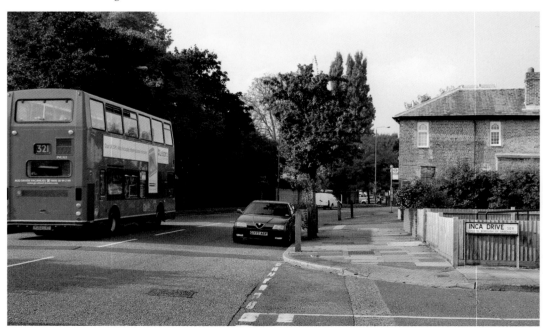

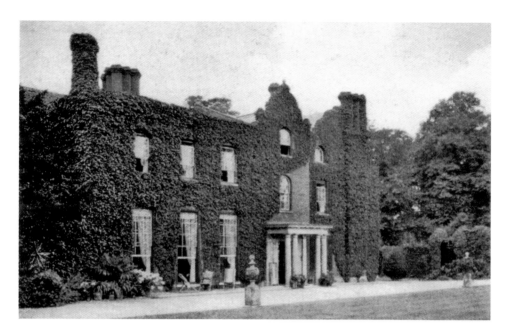

Southend House, c. 1909

Sir William Wythens, High Sheriff of Kent in 1609, held Southend House and its considerable appurtenances from at least 1605 until his death in 1631. He was buried at Eltham parish church on 7 December. The family continued in residence until the death of his grandson Sir Francis Withens in 1704, the latter a Judge of the King's Bench, who presided over the 'Popish Plot' trial of Titus Oates. Southend House has been converted into retirement flats, which were completed in 1990.

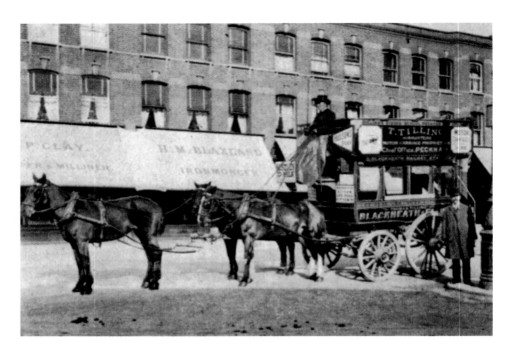

The Last Run of the Old Blackheath Bus, 1908

The old Blackheath Bus was run by Thomas Tilling Ltd, and connected Eltham Village with the London-bound trains leaving from Blackheath station. This 'Last Run' pictures the horse-drawn bus on the High Street, at the corner of Southend Road (now Southend Crescent). Inside and on the exterior top deck, it was able to seat twenty-six passengers in total. Tilling's launched its first motorbus on 30 September 1904, with its last horse bus run on 4 August 1914 (horses then being requisitioned for war work).

CHAPTER 4

Shooter's Hill

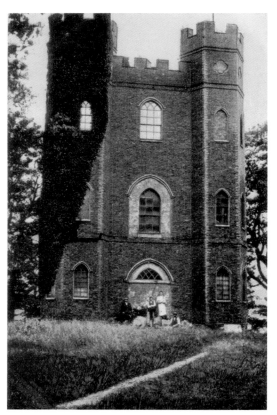

Severndroog Castle
Dame Anne James, wife of Sir William James, erected the magnificently eccentric folly of Severndroog Castle as a memorial to her husband's passing on 16 December 1783. He was buried at Eltham Parish church on 22 December. James' hereditary title of Baronet became extinct at the death of his only son, Edward William, aged eighteen, in 1792. The castle fell into disrepair, and despite donations raised from its entry in the BBC series *Restoration* in 2004, it remained graffiti-covered in 2007.

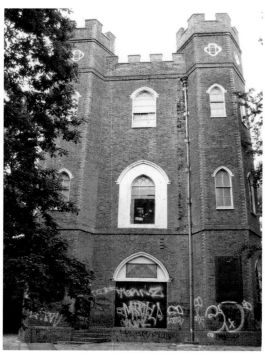

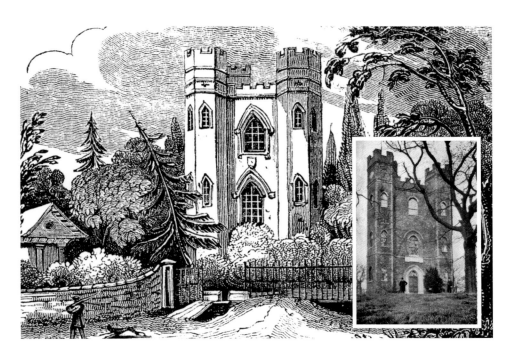

Severndroog Castle, 1825 Engraving and 1909 Photograph
The Folly was designed in 1784 by Richard Jupp, surveyor to the British East India Company, which had appointed James as Commodore and Commander-in-Chief of its Marine Forces in 1751. Its name commemorates Sir William's capture of the fortress of Suvarnadurg, here corrupted to Severndroog, off the Malabar Coast on 2 April 1755. The Severndroog Castle Building Preservation Trust was founded in 2003, and restoration at last made possible thanks to a Heritage Lottery Fund grant of £595,000 in 2010.

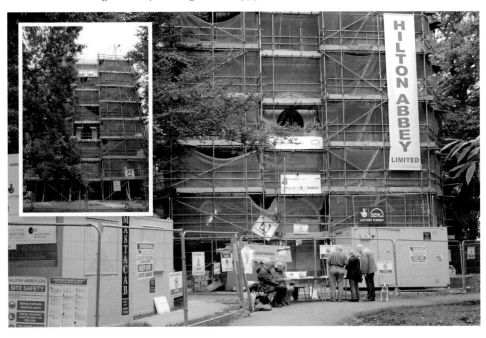

Crown Woods, Shooter's Hill, 1908
The Crown Woods, better known as Oxleas Wood, represents one of the few remaining areas of deciduous forest in Greenwich, dating in part to the Ice Age some 8,000 years ago. Included within the Royal Manor of Eltham in 1311, they were eventually leased from the crown to Sir John Shaw in 1679. The woods were taken over by the War Department in 1811, acquired by the London County Council in 1930, and opened to the public in 1934.

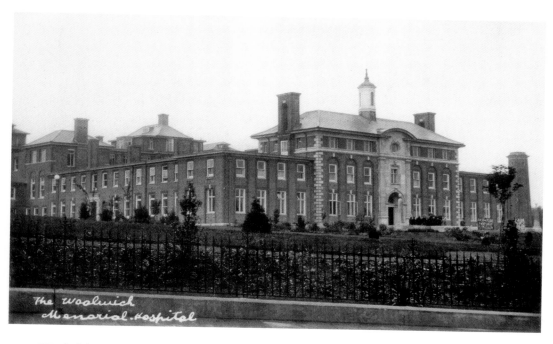

Woolwich Manorial Hospital

Originally known as the Woolwich & District Hospital Association Cottage Hospital, later the Woolwich & District War Memorial Hospital, and now more simply Memorial Hospital, it was built across 13½ acres on Telegraph Field (a former semaphore station during the Napoleonic Wars), off Shooter's Hill, as a memorial to the dead of the First World War. It became a military hospital during the Second World War, joined the NHS in 1948 as a general hospital, and is today used as a day-care centre with outpatient facilities.

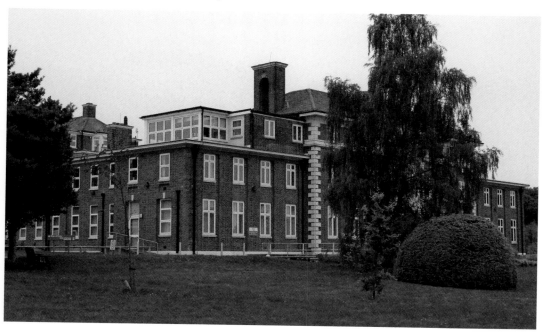

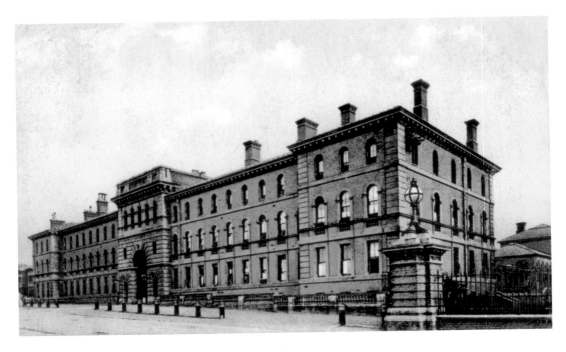

Herbert Hospital, 1905

Named after Secretary of State for War Lord Sidney Herbert, and built to accommodate the Woolwich Garrison, Herbert Hospital on Shooter's Hill opened in 1865, the first in England specifically designed to operate as a military hospital, on Florence Nightingale's Pavilion pattern. Made redundant by the opening of the Queen Elizabeth Military Hospital in Stadium Road, Woolwich, it closed in 1977, saved from demolition by attaining Grade II listed status. Redeveloped as luxury apartments, Royal Herbert Pavilions opened in 1995.

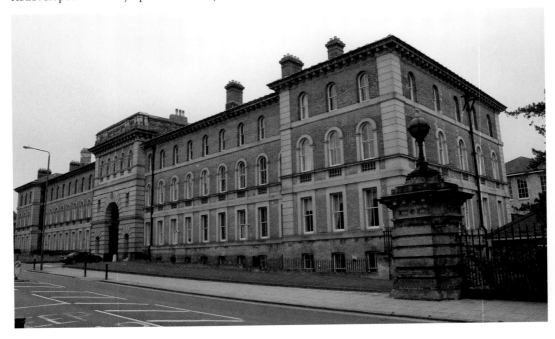

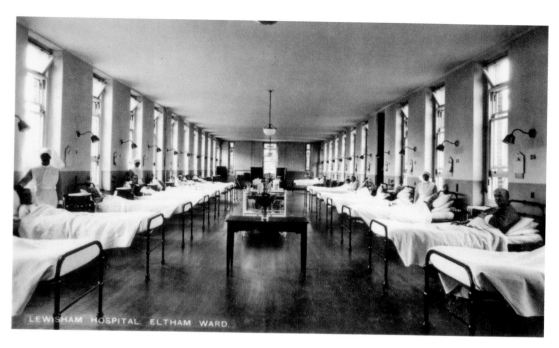

Lewisham Hospital, Eltham Ward and Emblem Above the Entrance to the Workhouse Hospital
Eltham was one of seven constituent parishes represented by the Lewisham Poor Law Union, formed on 28 November 1836. The nurses' headdresses above resemble those worn during the First World War, when the majority of Lewisham workhouse residents were relocated as its separate infirmary (opened in 1894) became the Lewisham Military Hospital. The Union Workhouse was closed in 1929. Despite the destruction of two wards in a V-1 bomb hit during the Second World War, the hospital has continued to expand, gaining university status in 1997.

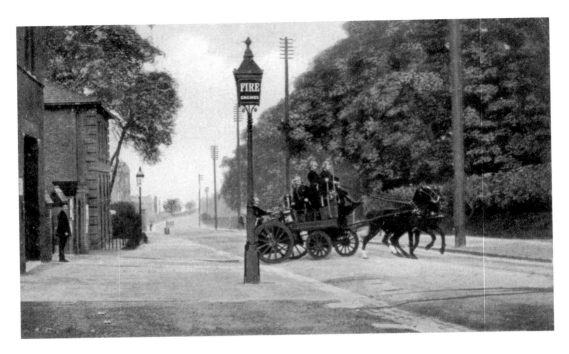

Fire Call at Shooter's Hill

The old fire station atop Shooter's Hill remained operative until 1998, when it was permanently closed by the London Fire Brigade. It is now a Grade II listed building, converted into flats for residential housing. The London County Council provided Eltham with its own fire station in 1904, in acknowledgment of its growing needs during the transition from rural to suburban village. Run with only one fire engine, it is among those Greenwich stations threatened with closure since autumn 2012.

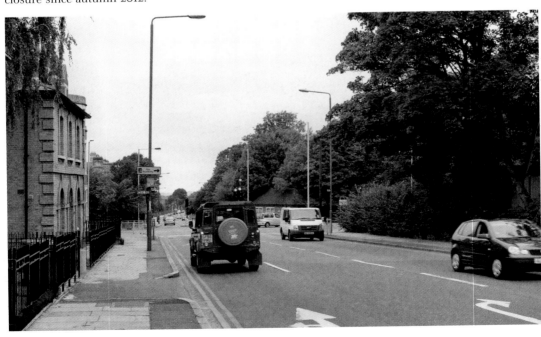

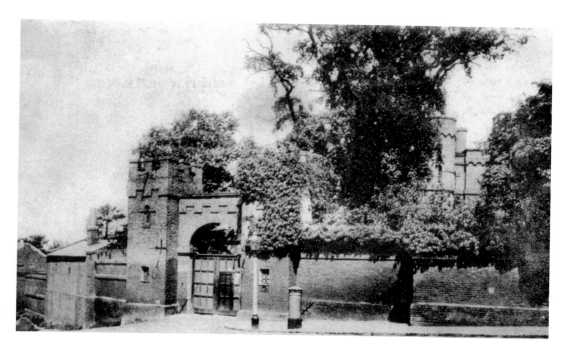

Vanbrugh Castle, 1905

Best known as the Baroque-style architect of Castle Howard and Blenheim Palace, Sir John Vanbrugh built Vanbrugh Castle on Maze Hill for his own family in 1719, while working as Surveyor to the Royal Naval Hospital in Greenwich. Also a noted playwright, his castle is theatrically medieval, with its towers, battlements and arches predating the first overtly Gothic Revival villa, Horace Walpole's Strawberry Hill, by thirty years. The exterior of the castle remains intact today, its interior converted to luxury flats.

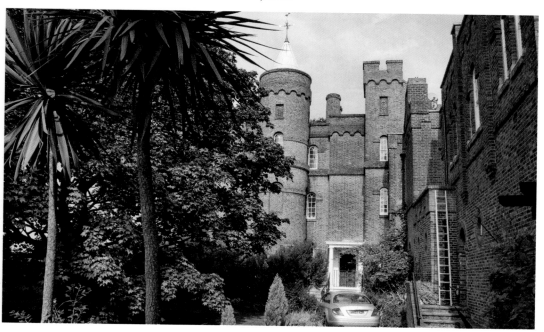

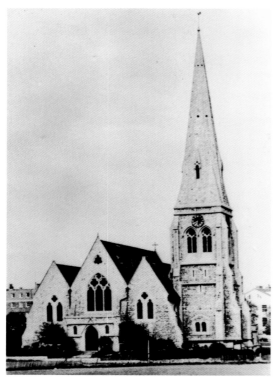

All Saints Church, Blackheath
'The church on the heath' was built
between 1857 and 1867 from designs
by architect Benjamin Ferrey, pupil
and biographer of the Gothic Revivalist
Augustus Welby Northmore Pugin. It
stands in proud isolation on the edge of
the common, facing Montpelier Row and
its elegant row of Georgian residences,
making no aesthetic compromise with its
backdrop. Registers of the parish church
of All Saints date from 1859, the year
Blackheath became a parish in its own
right, created from Lewisham St Mary.

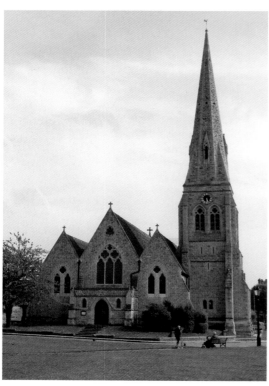

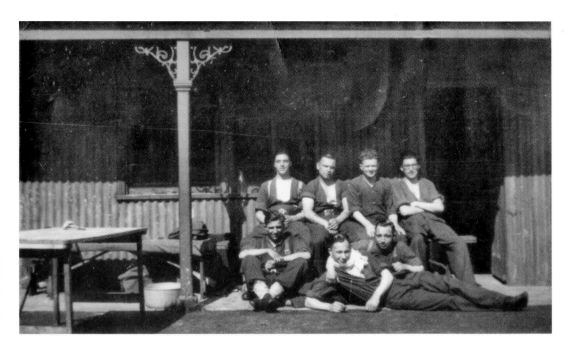

Troops Relaxing on the Heath, June 1941

A gathering point for Wat Tyler's peasant army in 1381 and Jack Cade's Kentish rebels in 1450, the common at Blackheath has housed temporary soldiers' encampments from the Monmouth Rebellion to the Second World War. Blackheath Common and Oxleas Wood were among local green spaces commandeered in July 2012 to accommodate the surface-to-air missiles that guarded Olympic sites. Residential use has since resumed, as families gather to relax by sailing boats on the pond and flying kites on the heath.

Acknowledgements

Time present and time past
Are both perhaps present in time future,
And time future contained in time past. (T. S. Eliot, 'Burnt Norton', *Four Quartets*)

No one exploring the historic byways of Eltham can fail to be indebted to the meticulous scholarship of schoolmaster R. R. C. Gregory, whose 1909 *The Story of Royal Eltham* conveys his passionate interest in his home village to a young readership without dumbing down in tone or content. Medieval charters and Tudor probate sourced for his book are described in a lively manner, which entice the reader to turn yet another page, while providing a form of internal bibliography, guiding one to the location of those original papers with minimal effort. I walked in his footsteps not only when taking photographs for this book, but also in archives and libraries, where I enjoyed reading through many of the early documents referenced in his *Story*. I am also indebted to two websites in particular, which provided sources for researching this book: the Internet Archive, a digital library of out-of-copyright materials, and the University of London's British History Online.

Warmest thanks to the staff at Eltham Palace and English Heritage for their help and permission to photograph inside the Great Hall; likewise to the supervisors at the Winter Garden, Avery Hill, and Southend House, and to Dave Kenningham of Folkmob for generously contributing the modern music photograph to balance the old. My thanks, too, to the many stallholders and auction-sellers with whom I enjoyed trading over the past year in my search for vintage photographs and postcard images, and to my parents for birthday-gifting me with a subsidy for their collection. Finishing the book will leave a void in my now traditional daily routine, though it will not diminish the keen interest I share with Mr Gregory in the history and beauty of Eltham itself.

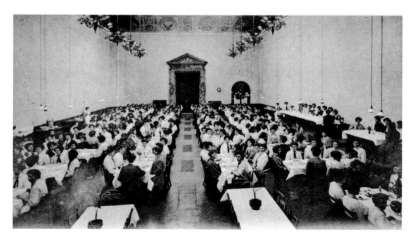

Dining Hall, Avery Hill College, Eltham Edwardian women reaping the benefits of higher education in the early years of the teacher training college.